IMAGES
of America

SYOSSET

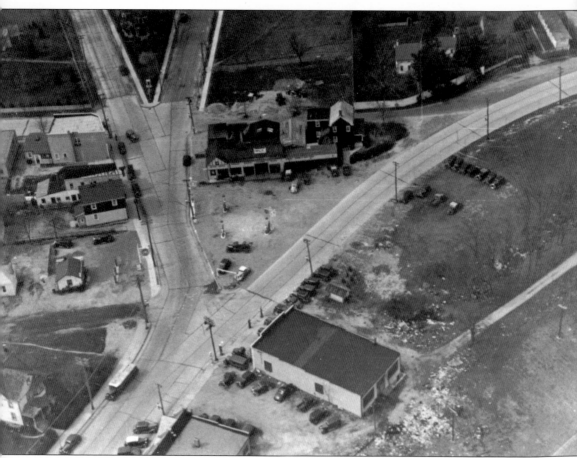

For its first 300 years, Syosset, once known as Eastwoods, was primarily characterized by vast acres of farmland and, later, by a small downtown area that emerged in the vicinity of the railroad station. When this aerial shot of the Jackson Avenue-Cold Spring Road triangle (center) was taken in 1937, Syosset's population was well below 2,000, and its main strip of retail stores was still in the planning stage. Eventually, Jackson and Cold Spring Roads were lined with shops and restaurants of all types, as were Jericho Turnpike and South Oyster Bay Road. Industrial complexes also sprouted up around the area, providing office and manufacturing space for some of the country's most prominent corporations. Nearby Woodbury, once spotted with large dairy farms, experienced similar growth in the 20th century and is today considered one and the same with Syosset proper. (John Schulz Jr.)

IMAGES
of America

SYOSSET

Tom Montalbano

ARCADIA

First printed in 2001.

Published by Arcadia Publishing,
an imprint of Tempus Publishing, Inc.
2A Cumberland Street
Charleston, SC 29401

Printed in Great Britain.

Library of Congress Catalog Card Number: 2001090419

For all general information contact Arcadia Publishing at:
Telephone 843-853-2070
Fax 843-853-0044
E-Mail sales@arcadiapublishing.com

For customer service and orders:
Toll-Free 1-888-313-2665

Visit us on the internet at http://www.arcadiapublishing.com

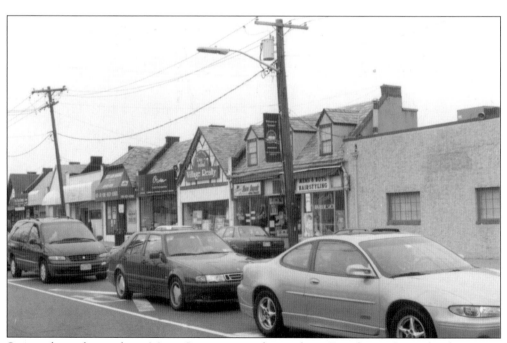

Some places have their Main Street; some have their Broadway. Syosset's downtown thoroughfare is Jackson Avenue, photographed in 2001.

CONTENTS

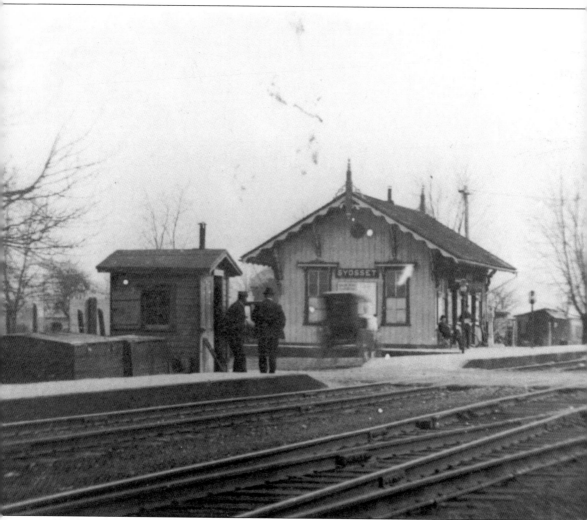

The development of Syosset's downtown area can be credited in large part to the presence of the Long Island Rail Road, pictured here in an early-1900s postcard view. Many of the images in this book originally appeared on postcards sold in the local general store and at local hotels during the early 20th century.

INTRODUCTION

To preserve the history of a community is an enormous responsibility. In the case of early Syosset, few official records exist with the exception of those incorporated into the Town of Oyster Bay archives. Therefore, piecing together an account that is both historically correct and interesting to read entailed a great deal of investigative work and many hours of conversation with longtime residents, merchants, town officials, and local historians. For helping to ensure that the information in this book is worthy of passing down to future generations, I would like to thank the following individuals and research institutes.

First and foremost, the Local History Room at the Syosset Public Library, under the care and administration of Isabel Goldenkoff and more recently Lisa Dettling, has been a vital resource. Isabel Goldenkoff, with whom I had the pleasure of producing a Syosset oral history series and a multimedia Syosset documentary in the early 1990s, can be credited with sparking my interest in local history. Lisa Dettling has been enormously generous in allowing me to reproduce numerous photographs, maps, documents, postcards, and news clippings. Both have helped make the process of writing this book a great deal of fun.

Much of the historical data included on the following pages was obtained from the Long Island Studies Institute at Hofstra University, the Department of Special Collections at State University of New York, Stony Brook, the Long Island Division of the Queens Borough Public Library, the Oyster Bay Historical Society, the Oyster Bay town clerk's office, and, of course, all of my former history teachers in the Syosset schools. When books and historical documents could not provide critical details, vintage newspaper clippings and early maps filled in.

Of course, there are times when even printed materials cannot provide all the answers to all the questions. At times like these, I am grateful to have been able to call on notable local historians such as Richard E. Evers, author of *Images of America: Hicksville* (who, by the way, introduced me to Arcadia Publishing and, therefore, is largely responsible for the book your are now holding), and Dorothy Horton McGee, official historian for the Town of Oyster Bay.

Another invaluable source of information (and photographs) are the many postcards that were published in small communities such as Syosset in the very early years of the 20th century. I am grateful to have been introduced to a large circle of Long Island postcard collectors by Carl W. Baker, a one-time Syosset merchant and avid researcher of Syosset's Native Americans. Baker's expansive Syosset postcard collection, acquired by the Syosset Public Library in 1999, is scattered throughout the following pages and in many cases represents the only available photographs of many key sites throughout the hamlet.

Longtime Syosset residents may recall a book entitled *Looking Back On Syosset*, written by Patricia Tunison in 1962 and 1963. I have always been a great fan of that book, and I am thankful to have had it as a reference throughout this project.

Writing a book about your hometown provides an opportunity to make many new friends and to rekindle some old friendships. The people I have met through my research and the hours I have spent conversing with them over the past 11 years made compiling this volume an absolute pleasure. A sincere thank-you goes out to Henry Marzola, Tony Maimone, and Frank Pepe, longtime residents who have contributed enormously to this project through their knowledge of Syosset history, their recollections of people and places, and their enthusiasm for keeping the stories of old-time Syosset alive. I would also like to thank the participants in the 1991 Syosset Oral History Project, which features comprehensive interviews with longtime residents and/or merchants including Carl Baker, Joseph Boslet, Sherwood Carl, Una O'Hagan DeGeorge, Ruth Flohn, Joe Hoda, Mary Moran Kennedy, Catherine Manelski, Virginia Hansen Monilaws, Frank O'Hagan, Herbert Payne, Elizabeth Williams Reynolds, Leonard Ricciutto, Dolly Ronis, Ted Swiencki, Charles Voorneveld, Karl Wozniak, and George Wulforst. Additional recollections of old-time Syosset were provided by John Delin, Maria Maimone, Bette Manarel, Judy Plant Manarel, Ross Manarel, and Maureen O'Brien. Thanks also to Edward Aulman, Stella Bartl (Framing Productions), Edwin Beatty, Edward Carr, John Catanzariti, Sam Mitchell, and Vincent Seyfried.

They say that every picture tells a story. In many cases, the only stories left about old-time Syosset are the photographs that have survived through several generations. Many of the photographs in this book were contributed by Pamela Boslet Buskin, granddaughter of Boslet Inn proprietor Joseph Boslet Sr. and daughter of Robert Boslet, former Syosset postmaster and an active community member his entire life. This book would not have been possible without Pamela Buskin's photographs and constant encouragement. Thanks also to Alan Boslet, son of Joseph Boslet Jr., and to Donald Boslet, who took many of the original photographs.

Finally, extra special thanks to my wife, Louise, for her patience and support throughout this project.

Syosset, a one-time remote farming settlement built on Native American hunting and camping grounds, has developed into a bustling suburb of homes, businesses, award-winning schools, and spacious playgrounds. Once part of a larger area known by early settlers as Eastwoods, the region now within the boundaries of the Syosset Central School District includes not only North and South Syosset, but Woodbury, Locust Grove, and Muttontown, as well as parts of Oyster Bay Cove, Laurel Hollow, and Jericho.

A 1922 publication distributed by the Long Island Real Estate Board stated: "While Syosset at the present time is not developed very extensively in the way of suburban homes, this is accounted for by the fact that this farmland is too valuable to be disposed of for development purposes. However, it is only a question of time as to when it will be transformed into a beautiful home community."

This is the story leading up to that transformation.

One

THE PLACE IN THE PINES

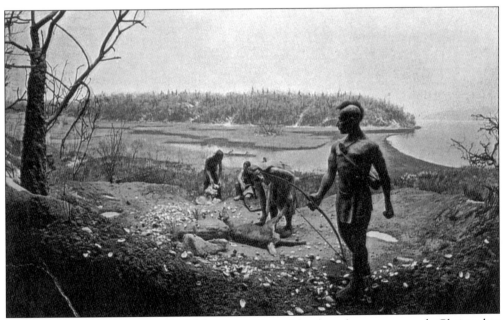

For thousands of years prior to the 17th century, Long Island was home to a people Christopher Columbus named "Indians," believing, when he stumbled upon America, that he had actually reached Asia. Early maps reveal that the area we now know as Syosset was part of a large region that its earliest inhabitants called *Matinecoc*. (Garvies Point Museum.)

Freshwater ponds such as this one at the fork of Syosset-Woodbury and Cold Spring Roads were a precious lifeline for Syosset's original natives, providing food and water for several generations before European settlers arrived. Syosset's earliest dwellers can be credited for introducing to the area corn, beans, and squashes, which, along with other crops such as potatoes and cabbage, became the foundation of Syosset's farming trade for centuries.

In the 1920s and 1930s, a wealth of information about Syosset's Indians was discovered in the Humphrey Drive area. This water basin behind the old Locust Grove School is the remnant of "Indian Hill," which acquired its nickname after local children discovered arrowheads, pipes, and human remains in the soil. When sand miners demolished Indian Hill in the early 1930s, more and more artifacts dating back to Syosset's indigenous people began to turn up, filling in pieces of the puzzle that was our past.

Henry Marzola displays some of the arrowheads he found on Humphrey Drive as a child. The discoveries led researchers to believe that a fairly large Native American population might have used Syosset as hunting grounds prior to the 1600s. Perhaps the most telltale evidence was a large open meadow surrounded by a thick pine tree grove found near Humphrey Drive. Early hunters generally cleared a field into which they would chase their prey from the surrounding woods. Once an animal was out in the open, the hunters used their chiseled stone arrowheads to slay it.

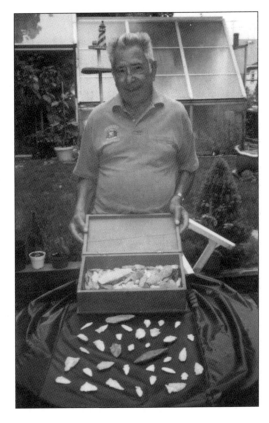

While Native Americans dug their roots deep into Syosset, two powerful European countries were gearing up to settle new lands in the west. In the early 1600s, the Dutch and later the English landed on Long Island, where the two groups engaged in a series of battles and negotiations with the natives and then ended up facing off against each other. At first, a dividing line gave the Dutch control of the land west of the present-day Oyster Bay Township and the English control of the land to the east. By 1674, the English had taken control of the entire island by force. (New York State Museum.)

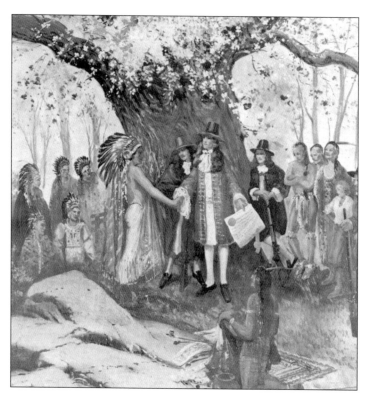

First, though, shrewd settlers clamored for pieces of this new world. In 1648, Englishman Robert Williams convinced the Matinecoc leader Pugnipan to sign over a large tract of land that included present-day Jericho, Syosset, and Woodbury in exchange for a few dollars' worth of cloth. Pugnipan's people must have felt they got the better end of the deal, as Native Americans did not understand the concept that land could belong to any man. (Painting by Joseph Physioc, 1930s; Richard Evers, Hicksville Gregory Museum.)

Robert Williams turned a profit on his investment in 1653 by reselling the land to a group of Rhode Island men who wanted to establish a settlement they named Oyster Bay. As part of the deal, Williams received some of the best acreage for himself. The rest was divided among Dutch and English settlers who gave their communities distinctive names such as Eastwoods, which comprised the present-day Syosset-Woodbury area. Some of the earliest family names in Eastwoods were Van Sise, Boerum, Van Der Vanter, Birch, Van Nostrand, Snedeker, Wycoff, Emons, Remson, Sanford, and Schenck.

TOWN OF OYSTER BAY · NEW YORK ·

1653

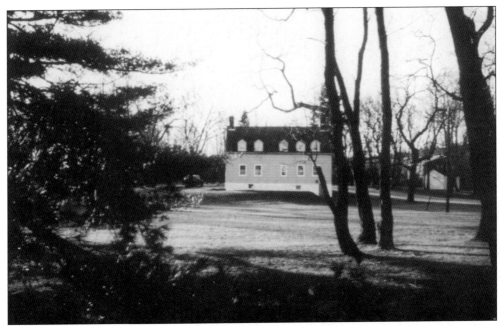

The Schenck family, Dutch pioneers who came here in the late 1600s, had 97 acres covering almost all of Convent Road and extending as far north as the present-day railroad crossing at Syosset-Woodbury Road. The Schenck residence, photographed in 1991, still existed on Convent Road more than 300 years later, as did the family cemetery located across the road.

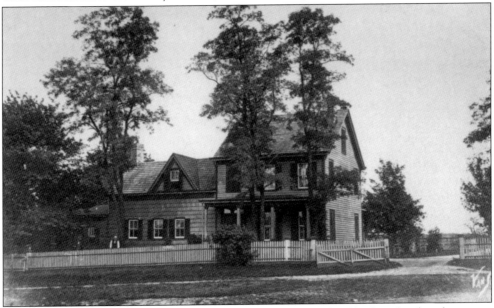

One of the earliest Eastwoods families of English descent was the Cheshire family, who at one time owned almost all the property that comprises today's downtown area and beyond. In 1832, David Cheshire married Elizabeth Schenck. The wedding, between an English groom and a Dutch bride, suggests that English-Dutch relations had settled down somewhat by the 19th century. This early-1900s photograph shows the Albert Cheshire house at the corner of Jackson Avenue and Ira Road. (Carl Baker.)

From what we know, the Dutch and English families of Eastwoods lived in reasonable harmony, separated only by their large farmsteads. The home was the center of activity, where family members gathered around a crackling fire to discuss the day's events and where children played on a floor made of white sand. To preserve food, settlers cut chunks of ice from local ponds and stored them in a building called an icehouse, which had double walls stuffed with straw, sawdust, or salt hay to delay melting. For the most part, farming families were self-sufficient. However, what they could not produce themselves, they would often barter from others. This c. 1930 photograph shows one of the more elaborate icehouses in our area, one that shared quarters with a carriage house on the Jackson property, at the corner of Jericho Turnpike and Jackson Avenue. (Syosset Public Library Local History Room.)

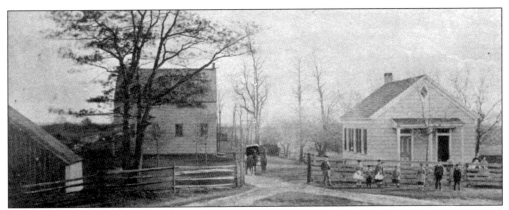

Many of the early English settlers in Eastwoods practiced Quakerism, an unconventional religion that was frowned upon both in their native England and on Long Island. When the British took control of New York in the 1670s, new religious tolerance laws gave Quakers the freedom to worship as they pleased. In 1788, the Religious Society of Friends established a Quaker meetinghouse on Old Jericho Turnpike and today's Route 106. Pictured are the meetinghouse (left) and the school (right), with pupils, c. 1875. (Kathryn Abbe, Jericho Friends Meeting.)

Throughout most of the American Revolution, from the 1776 Battle of Long Island (depicted in this J.C. Armytage painting) to the war's end in 1783, Eastwoods was occupied by British and Hessian troops, who reportedly set up camp on Jericho Turnpike across from the present-day hospital. Officers took over local homes, seized livestock, and demanded that the landowners meet quotas on food, firewood, and other provisions. When the war was over, the British soldiers left behind muskets, medals, and letters, which were discovered when ground was broken for the Villa Victor restaurant in 1934. (National Archives.)

Shortly after the Revolution, Townsend Jackson purchased several hundred acres at the corner of what is now Jericho Turnpike and the north-south street that was then called Oyster Bay Road. The property, which extended as far north as Teibrook Avenue, passed through several generations and eventually belonged to Jacob W. Jackson, the owner of a large trucking concern in New York. In Jackson's day, the trucks were pulled by horses, which he brought out to his ranch every so often for a few days of rest. The thoroughfare that paralleled the Jackson property was later named Jackson Avenue. (Carl Baker.)

"Stray—The owner of a large Bay Horse, appears to have done considerable servise. May hear of him by inquiring of Henry Fleet, Syossett." This handwritten entry from the official Town of Oyster Bay records suggests that the name "Syossett" had replaced Eastwoods as early as May 23, 1846. However, the Syosset that Fleet called home was actually the hamlet of Oyster Bay, which used the name Syosset between 1845 and 1848 in an effort to distinguish itself from the larger Oyster Bay Township. (Office of the Town Clerk, Town of Oyster Bay.)

Meanwhile, by the late 1840s, Eastwoods residents had established a number of subdivisions within their community, giving them distinctive names such as Locust Grove, Woodbury, and Southwoods. By then, the northwest section (today's downtown area) was known as Little Eastwoods, a name with which its residents apparently were not pleased. The name Syosset, recently abandoned by the hamlet of Oyster Bay, seemed a suitable replacement. Many believed Syosset was derived from the Algonquin Indian word *Suwasset*, meaning "Place in the Pines." Others insisted it had evolved from the Dutch word *Syocitis*, a derivative of *Schouts*, meaning "sheriff."

While the people of Little Eastwoods debated over a new name for their remote community, a revolutionary new form of transportation was changing the face of *all* Long Island communities.

17

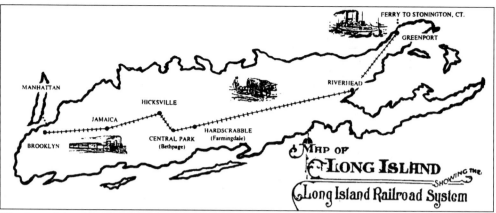

The Long Island Rail Road (LIRR) was designed to carry manufactured goods from New York to the bustling seaport city of Boston. Railroad engineers proposed a route using Long Island as a right-of-way to Greenport, where ferries could carry passengers and freight to meet Boston-bound trains in Stonington, Connecticut. The original line opened in 1844 and passed as close to Syosset as Hicksville. Four years later, competing railroad companies merged and created a much faster, more direct New York-to-Boston railway through Connecticut, nearly putting the LIRR out of business.

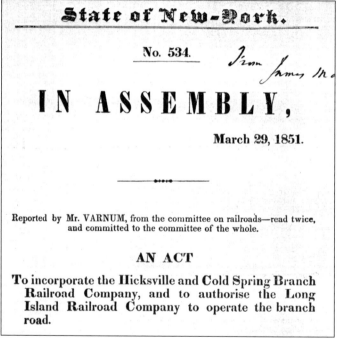

The Long Island Rail Road's dilemma provided a golden opportunity for the prominent Jones family of Cold Spring (today, Cold Spring Harbor), who believed their various enterprises could greatly benefit from improved railroad access. In March 1851, three Jones brothers struck a deal with the LIRR to build a rail extension from Hicksville through Syosset into Cold Spring. Construction began in early 1854 and by summertime, the tracks reached Willis Avenue just west of Jackson Avenue. If questions still remained about the official name of the area at this point, the LIRR put them to rest forever when it named the new station "Syosset." (Nassau County Museum, Long Island Studies Institute.)

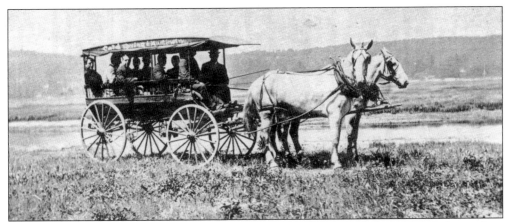

What happened next sparked a period of unprecedented growth for Syosset. As workers proceeded with the track extension, they proved to be no match for the massive hills of Woodbury. Discouraged and short on funds, the Jones family abandoned the project, leaving Syosset as the end of the line for the new branch. Now, farmers and merchants from surrounding areas who wanted to take advantage of the railroad had to use Syosset as a starting point. Almost overnight, activity in Syosset soared as masses of north shore farmers arrived each morning by horse-drawn carriage to ride the train to market. To accommodate these weary travelers at the end of the day, Peter Bell opened a hotel by the side of the tracks. In the morning, commuters could rely on stagecoach services (such as this one run by the Jarvis's of Cold Spring) for a ride home. Suddenly, Syosset was booming. (Madeline Stoots.)

Amos Boerum's Yellow Stage Company, with headquarters next to the Bell Hotel on present-day Railroad Avenue, was perhaps Syosset's most active taxi stand in the mid-to-late 1800s. Because horses could kick up a good amount of dust on Syosset's dirt roads, farmers getting off the train raced to get the first stagecoach out so they would not have to choke on the powder from stages in front of them. This photograph, although taken more than 50 years after Amos Boerum set up shop, is one of the only existing reminders that there was life in Syosset before automobiles. (Pamela Boslet Buskin.)

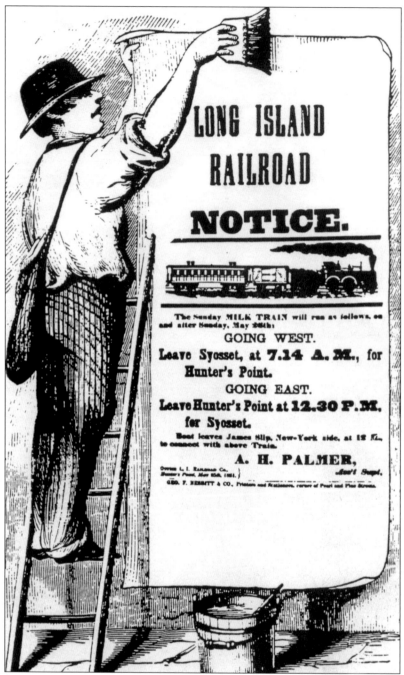

Not all Syosset residents accepted the railroad with open arms. Many argued that the speeding trains burned up their property and killed their precious livestock. Others objected to the milk trains that ran through Syosset on Sundays, the traditional day of rest. "Better that all men in New York and Brooklyn should drink water for one day than the morals of the people should be destroyed," declared one local newspaper editorial. Nevertheless, progress marched on, and the railroad soon became an indispensable commodity for residents of Syosset and its surrounding communities.

Two

THE MAIL, THE CHURCH, AND THE CIVIL WAR

As early as the mid-1700s, mail entered the Eastwoods area via horse-drawn cart by way of the Post Road, which historians believe included part of what is now Woodbury Road. This Colonial-era structure on Woodbury Road, which housed the Baylis General Store in the early 1900s, is believed to have been the site of Woodbury's first post office in the 18th century, and therefore the first post office in the entire Eastwoods area. (Post rider history courtesy of John Hammond; photograph by Bill Clarke.)

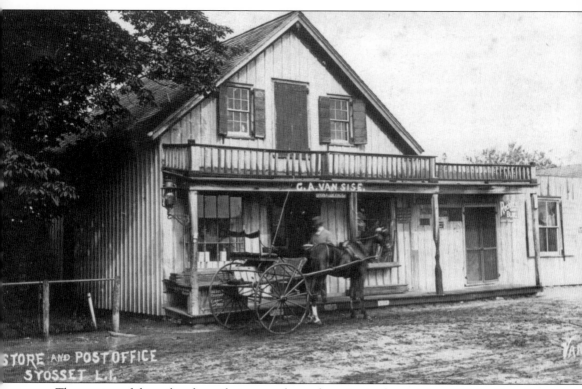

The coming of the railroad greatly improved postal service in the vicinity of Hicksville, where G.W. Totten unloaded mail from the train and delivered it by horse-drawn carriage to surrounding communities. In 1855, the town of Oyster Bay established an official Syosset Post Office, naming Philetus Ketcham its first postmaster. Two years later, the office moved into the Van Sise General Store on Berry Hill Road, where Syosset residents could not only pick up and drop off mail but also obtain horse feed, farm tools, and other necessities. Cash was rare in those early days, so Van Sise commonly accepted a peck of beans or a few chickens as barter for some sugar or a pair of work boots. Imagine the difficult time he must have had balancing his books at the end of the year. This photograph shows the Van Sise General Store and Post Office, located just north of the Split Rock-Berry Hill fork, sometime in the mid- to late 1800s. (Carl Baker.)

Over the next 80 years, the postmaster duties passed from one local businessman to another, usually the one with the most political connections in the Town of Oyster Bay. The post office was set up wherever the postmaster operated his shop and was typically the center of most social activity in town. The Devine Brothers General Store (right), at the corner of Jackson Avenue and Convent Road, served as a post office between 1896 and 1900. Although this late-1800s photograph does not show much of the store, it does provide a good view looking north on Jackson Avenue, which still had a packed dirt surface. (Carl Baker.)

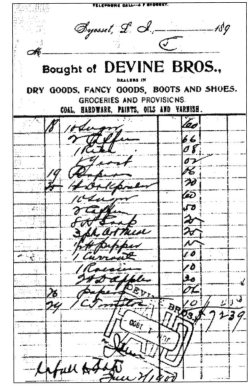

It may be the "old math," but somehow the numbers on this June 1900 receipt do not add up. Like the Van Sise store across town, Devine's served as a weighing station for farmers who shipped their crops to market by rail. (Elizabeth Williams Reynolds.)

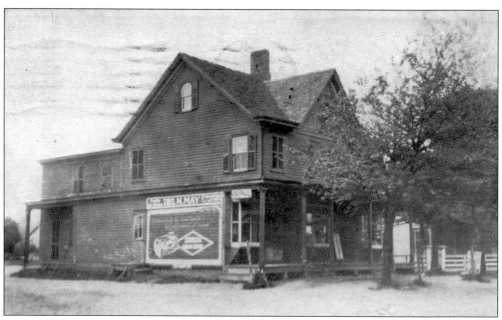

In the late 1800s, the Devine Store was leased to Theodore May, who continued to operate it as a general store. Interestingly, May's sister was married to Sidney Van Sise, a relative of the Van Sise who ran the competing general store on the other side of the railroad tracks. (Carl Baker.)

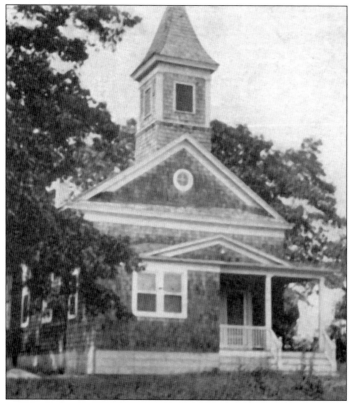

In 1860, as America teetered on the brink of civil war, a religiously diverse group of residents formed a committee to discuss building a church in which they all could worship. On little more than an acre of donated land, they built the Free Church of Syosset (later renamed the Community Church) between Berry Hill and Split Rock Roads. The Free Church, photographed here in the early 1900s, was nondenominational and welcomed any preacher of any religious background to stop in and lead a service. (Carl Baker.)

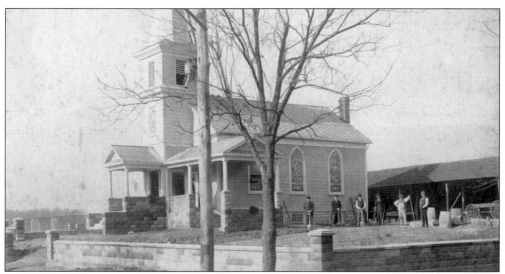

In 1844, the original Woodbury United Methodist Church, built at a cost of $600, opened its doors on Jericho Turnpike just west of Woodbury Road. For several years prior, the Methodists had held services in the Woodbury School on Jericho Turnpike. The new church, under expansion here in the late 1800s, served area Methodists until 1959, when a new, larger building was constructed south on Woodbury Road. (Woodbury United Methodist Church Archives.)

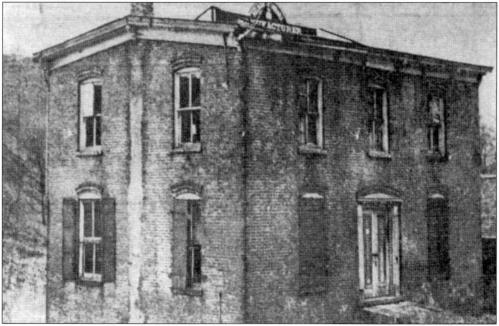

Ironically, the onset of America's Civil War, in 1861, ensured that Syosset's first golden age continued a few years longer. A wartime steel shortage brought eastward expansion of the Long Island Rail Road to a standstill, enabling Syosset to maintain its stronghold as a north shore transportation center. Meanwhile, at least one local business, Joseph Dowden's Tanning Factory, on Woodbury Road, continued to thrive during the war by manufacturing calfskin drumheads for the Union army. (*Long Island Daily Press*, April 1936.)

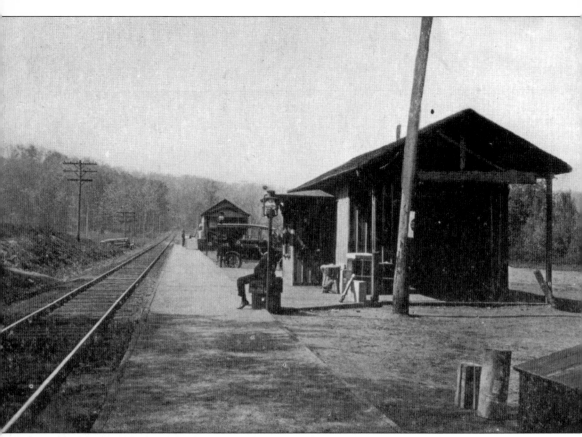

Shortly after the war's end in 1865, the Long Island Rail Road managed to reroute its tracks around the hills of Cold Spring to a point within a mile and a half of downtown Huntington. Unfortunately for the Jones family, this new route bypassed their village by nearly three miles. To compensate, in 1875, the railroad built a station in nearby Woodbury, shown here in the late 1800s. In 1889, the railroad added an extension to Oyster Bay, and soon the Syosset train station was no longer the only convenient shipping depot for local farmers. (Robert Emery LIRR Collection, SUNY at Stony Brook.)

Three

THE TURN OF THE CENTURY

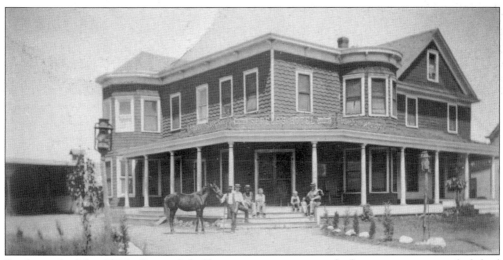

By the end of the 1800s, Syosset's half-century reign as a north shore transportation hub had come to an end. Consequently, the hamlet's once thriving hotel business fell on hard times. Fortunately, at the beginning of the 20th century, the construction of massive new estates (discussed in the next chapter) created a slow but steady demand for rooms for the carpenters, keeping the local hotels alive. Spreer's Hotel, shown here c. 1910, was located on the west side of Jackson Avenue, just south of Whitney Avenue. Yanke Spreer's establishment had 12 bedrooms, several dining and meeting rooms, and a large stable (left), in which Theodore Roosevelt reportedly boarded his horse whenever he used the Syosset train station. According to early-20th-century residents, Roosevelt preferred traveling in and out of Syosset when shuttling between Washington, D.C., and his summer retreat in Oyster Bay. This may have ended when, in 1903, Secret Service agents arrested a heavily armed man who identified himself as Henry Weilbrenner, a Syosset farmer, on the grounds of the grounds of Sagamore Hill.

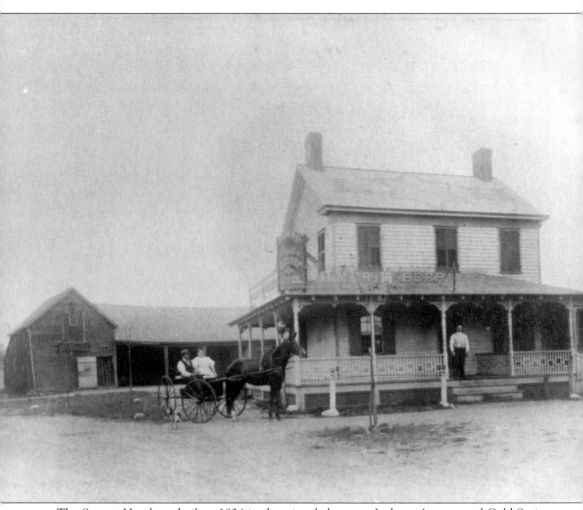

The Syosset Hotel was built *c.* 1824 in the triangle between Jackson Avenue and Cold Spring Road. When Sebald Lang took it over in 1899, there were 10 rooms, for which guests paid $1.50 per day. Ulmer Beer, advertised in this 1907 photograph, sold for 5¢ a glass, and a thick ham sandwich was just 10¢. According to folklore, Lang's Syosset Hotel was the scene of the first local sighting of a horseless carriage when, before the beginning of the 20th century, Fred Duggan of Locust Valley hitched a motor to his buggy and chugged all the way to Syosset. Duggan's primitive automobile reportedly caused a near riot in the village. Horses snorted and reared in dismay, and small boys shrieked the cry of the day: "Git a horse, Mister, git a horse!"

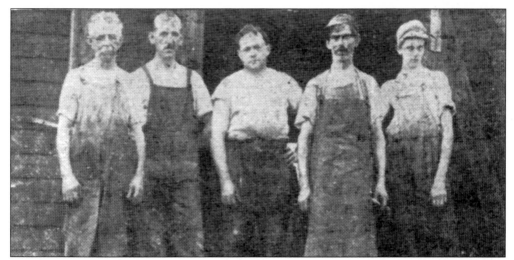

By the early 1900s, in a rickety, windowless factory beside the railroad tracks, the McGuire Pickle Works was brining and barreling trainloads of pickles and sauerkraut each day, creating quite a stink throughout the village. Many of the pickle workers were homeless men from New York City who received $9 a week pay plus sleeping quarters in a small bunk house next to the factory. Shown *c.* 1910 in front of the factory are, from left to right, George Vincent, Henry Smith (superintendent), two unidentified workers from New York City, and James DeMilt. The McGuire Pickle Works flourished until *c.* 1920, when a blight destroyed the bulk of the local cucumber crop. (Patricia Tunison Preston, *Looking Back On Syosset.*)

Although no known pictures of the original pickle factory have survived, this 1949 photograph (looking west)of the train station, shows the factory (left forefront) when it was used as a storage building for John Young's Syosset Coal Yard. (Robert Emery LIRR Collection, SUNY at Stony Brook.)

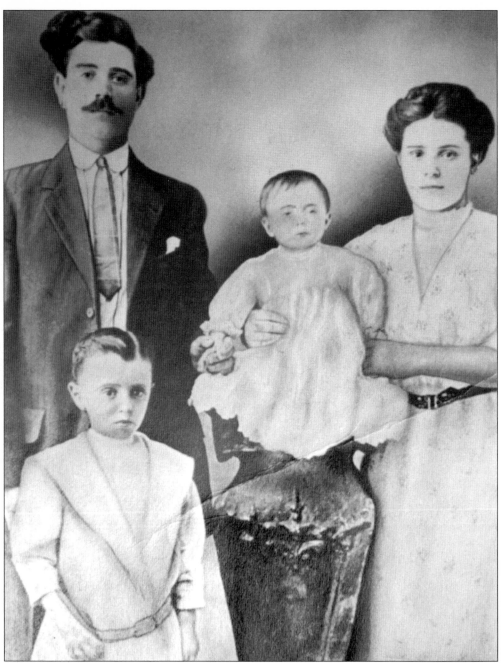

The pickle factory did not only employ vagrants and children. First-generation European immigrants, including Gaspar Puccio, an Italian who spoke very little English when he came to Syosset in 1902, often found their first jobs there. After a few years at the pickle factory, Puccio began moonlighting as a barber from his home on Richmond Street. By the time the factory closed down, the barbershop was so successful that Puccio moved the business into Yanke Spreer's Hotel and then into a small shop next door on Jackson Avenue. Here, he and Josephine Puccio pose with the first two of their eight children, Tony and Sadie, in 1911. (Rosaria Cuccino Glaser.)

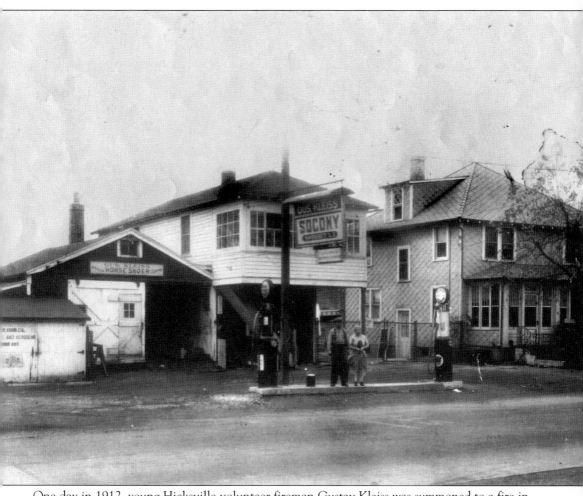

One day in 1912, young Hicksville volunteer fireman Gustav Kleiss was summoned to a fire in a remote community called Syosset. The wide-open space and vast potato fields made such an impression on Kleiss that he soon took an apprenticeship with the local blacksmith, John Walters, and became a Syosset resident. Eventually, Kleiss took over the blacksmith shop on Jackson and Willis Avenues and built a successful business making horseshoes and carriage wheels. According to Kleiss, he earned the money to purchase the shop in a Jackson Avenue horse race of questionable integrity. In later years, as this 1920s photograph illustrates, blacksmiths like Kleiss often supplemented their horseshoe business by installing gasoline pumps. (Raz Tafuro.)

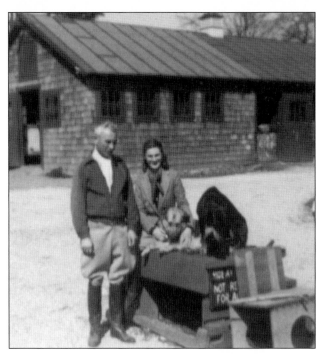

One of Gus Kleiss's best customers in the 1920s was Theodore Galitzan, also known as "Galiza," a Russian immigrant who ran a successful riding academy on the south side of Convent Road, just east of Jackson Avenue. The colorful "Colonel" Galiza made a name for himself boarding and renting prizewinning horses, giving riding lessons, and running spectacular horse shows along Convent Road. When a wrecking crew accidentally destroyed his stable in the mid-1940s, Galiza relocated to a 5.2-acre property at the corner of Muttontown and Split Rock Roads, where this photograph of him and his wife, Pauline, was taken in 1955. (Pauline Hise Galiza.)

Theodore Galiza married Pauline Hise, a Syosset teacher, in 1954. By this time, the Galiza stables housed 45 horses, including several belonging to the elite families of Syosset's "Gold Coast" mansions. When European royalty visited the estates, they would almost certainly schedule riding time at Galiza's. Legend has it that even Jacquelyn Bouvier Kennedy took a lesson or two at Galiza's before becoming first lady. Here, Pauline Galiza is pictured with Lawless Lady in 1955. Three years later, her husband passed away. The stable was sold in 1972 and was converted into senior housing. (Pauline Hise Galiza.)

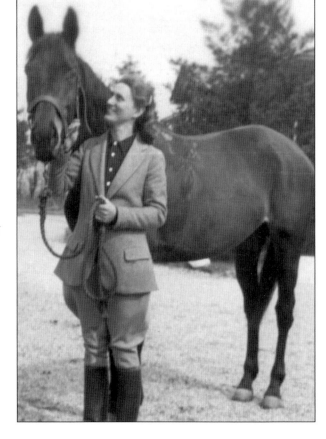

Four

THE GOLD COAST

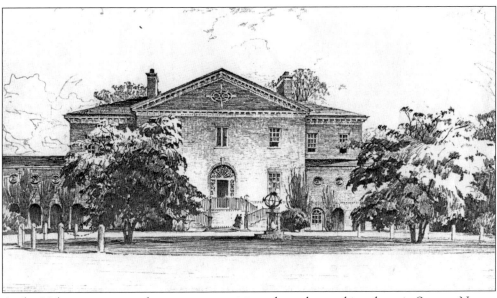

As the 20th century got under way, an unanticipated trend was taking shape in Syosset. Nassau County had just been established, and owning property within its boundaries quickly became a status symbol. Suddenly, affluent businessmen from Manhattan and Brooklyn were attracted to Syosset not only for its accessibility by train but also for its vast wide-open spaces on which they could build extravagant country homes and throw outrageous parties. By the dawn of the 1920s, some of New York's most prominent CEOs, steel moguls, and financiers had established magnificent estates throughout the area. (Drawing of J. Burden Estate, 1922, by Chester B. Price.)

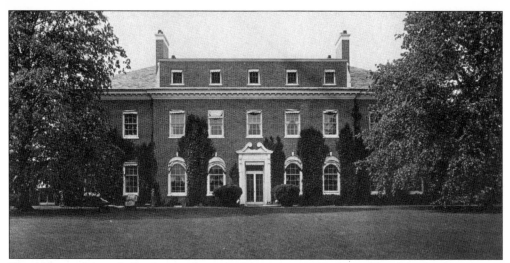

The 130-acre James A. Burden residence on Muttontown Road was one of the liveliest estates on what became known as the Gold Coast. James A. Burden, who built this extravagant mansion on the former Willis farm in 1916, was the son of Henry Burden, inventor of the world's first automated horseshoe manufacturing machine. His father earned his fortune during the Civil War, providing horseshoes for the Union army. The Burden estate had many servants, including several whose sole responsibility was to run a private dairy farm. (Syosset Public Library Local History Room.)

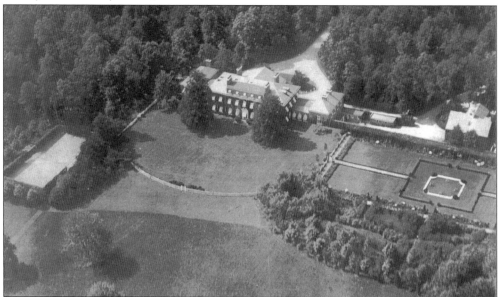

Perhaps the most notable event to occur at the Burden Estate was a 1924 visit by Prince Edward of Wales, the future King Edward VIII. The prince's visit was eagerly anticipated and followed by the press, who set up headquarters at the Syosset train station. In his autobiography, Edward implies that the parties he attended during his visit to the Gold Coast were so reckless that his father, King George V, banned him from ever returning to America. This 1920s aerial view shows Burden's tennis courts, spectacular gardens, and rare Black Angus cows, which were free to roam right up to the home's windows. The Burden Estate eventually became the Woodcrest Country Club. (Syosset Public Library Local History Room.)

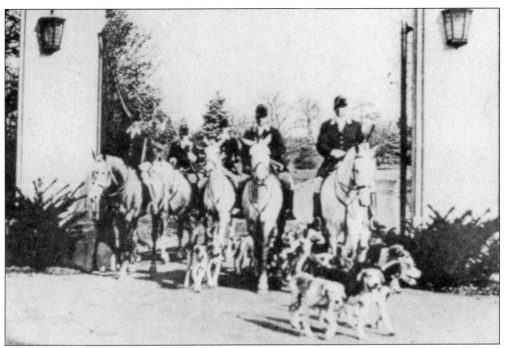

Some of the most celebrated activities in Syosset during the Gold Coast era were the fox hunts, which usually began at the Burden Estate and attracted numerous wealthy participants from all over Long Island. (Leonard Ricciutto.)

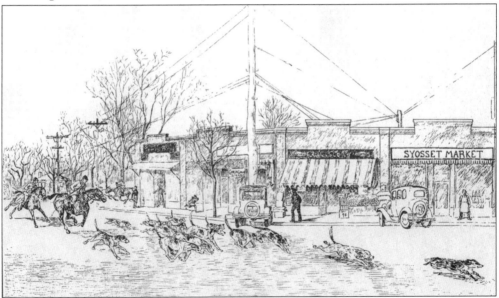

With the sound of a horn and cries of "Tallyho and away we go!" impeccably uniformed riders headed into the woods, through the front gates, or in whichever direction the dogs led them, in search of the agitated fox. The high-speed chase usually lasted for hours, much to the amusement of local children, whose mothers would warn them to "Get off the road! The dogs are coming . . . the dogs are coming!" This 1930s illustration by Elisabeth Babcock captures a typical fox hunt scene in the downtown area. (Syosset Public Library Local History Room.)

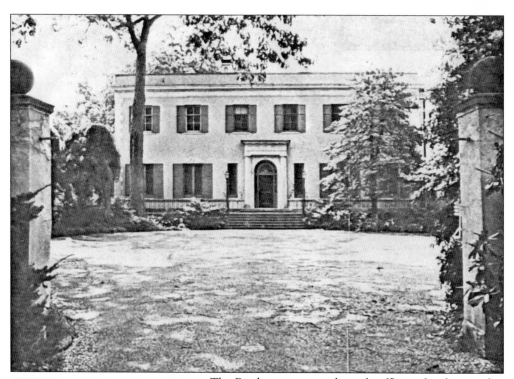

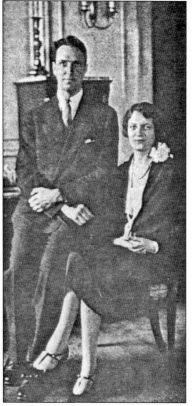

The Burdens were not the only affluent family to make their way to Syosset in the early 1900s. The present-day town golf course, on Southwoods Road, formerly belonged to Ailsa Mellon Bruce, heiress to the fortune of Andrew Mellon, a banker, entrepreneur, and former U.S. secretary of the treasury. Andrew Mellon purchased the estate for his daughter, Ailsa, upon her wedding to diplomat David Bruce. The Bruces, who eventually owned seven apartments in New York City and three estates in New Jersey, spent only three weeks of the year at the 121-acre, 32-room estate in Syosset, but kept a staff of 12 domestic servants and 22 gardeners year-round. (Syosset Public Library Local History Room.)

The Bruce estate boasted nearly $35 million worth of art and an enormous collection of rare foliage from around the world. When the couple divorced in 1945, Ailsa Mellon Bruce took over the estate and used it as a weekend getaway. Her daughter, Eliza, who would have been the sole heiress to the $500 million Bruce fortune, mysteriously vanished in an airplane over the Bermuda Triangle. In 1974, five years after Ailsa Bruce passed away, the Town of Oyster Bay condemned her property and eventually converted it into a golf course. (Syosset Public Library Local History Room.)

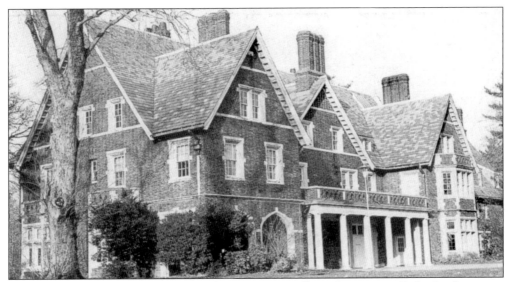

The 200-acre parcel now occupied by the Syosset-Woodbury Community Park, the Crossways Industrial Complex, and the Harry B. Thompson Middle School was once part of an estate called Woodbury House, built in 1915 for the celebrated polo player J. Watson Webb. When Manhattan financier Edward Tinker purchased the estate in the 1930s, he converted on section into a turkey farm and invited locals onto his property each Thanksgiving for a free-for-all turkey shoot. (Syosset Public Library Local History Room.)

One of the largest and most successful steamship enterprises of the early 1900s was the Cunard Steamship Line, whose North American chairman was T. Ashley Sparks. Before the 1920s, the flamboyant Sir Sparks and Lady Sparks built an enormous 42-room mansion on 300 acres along Berry Hill Road, stretching from Schoolhouse Lane to beyond Route 25A. A generous and sociable pair, Lord and Lady Sparks became one of Syosset's most celebrated couples, donating large sums of money and land to local organizations, sponsoring various types of activities for local children, and even providing hot soup and apples for the students at the Syosset School during the Depression. (Syosset Public Library Local History Room.)

Another shipping magnate, Robert E. Tod, once owned practically all of Muttontown Road, with 400 acres stretching from Split Rock Road to Route 106. After building this mansion just prior to the 1920s, Tod began selling off large parcels of his property. A devout supporter of Republican presidential candidate Thomas E. Dewey, Tod committed suicide the night Dewey lost the 1944 election to Franklin Delano Roosevelt. (Ted Swiencki.)

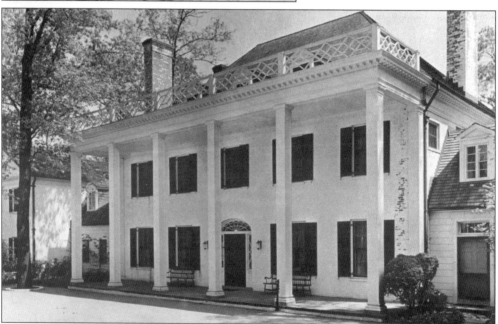

George and Franklin Lord were partners in a successful Manhattan law firm. In 1927, the brothers built side-by-side country mansions on a huge parcel of land along Split Rock Road. Also devout Republicans, the Lords staged many extravagant political campaign rallies on their estate during the 1930s, complete with live elephants to represent the Republican party. This photograph, taken in 1937, shows the George DeForest Lord mansion, which later became the Christian Fellowship Home for Adults. (Syosset Public Library Local History Room.)

One day in the late 1940s, William Willock of Muttontown Road strolled into Wilton Wood Lumber Supply, on Jackson Avenue, and asked the manager to order an unusually large quantity of railroad ties. He told the manager he was going to build a railroad on his estate. At first the manager was wary of the man's request, but a customer assured him that Willock could well afford the lumber and would indeed use it to build his own railroad. The railroad ties were ordered and, sure enough, within a few months, the first mini-locomotive chugged its way across Willock's property, near the corner of Muttontown Road and Route 106. (John Willock.)

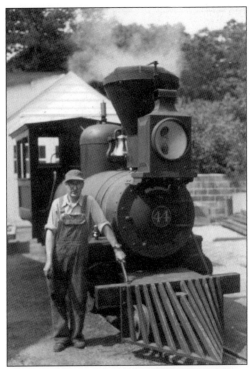

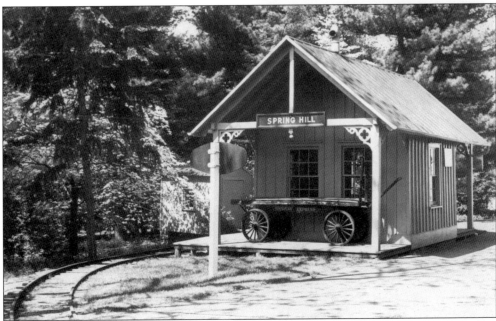

William Willock inherited the property in 1939 from his father, William Willock Sr., who had purchased the 200-acre parcel in the late 1920s. Willock's railroad started out with two cars and gradually expanded into a very impressive system with overpasses, an engine shop, water towers, and even this station house—an old shoe repair shop that had been moved from Split Rock Road. Visitors always looked forward to a private rail tour, and Willock was always happy to oblige. (John Willock.)

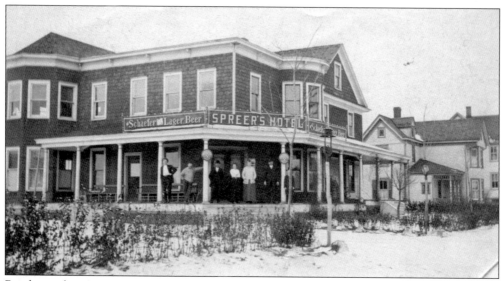

By the early 1900s, construction workers from the estates were about the only source of business for Syosset's hotels To make matters worse, even restaurant and bar receipts diminished when the National Prohibition Act of 1919 banned the sale of alcohol in establishments such as Spreer's Inn. Shortly after Prohibition took effect, Yanke Spreer sold his inn, shown here in the 1920s, to George Hillsdon who, in turn, sold it to Edward Rheinhard. Both had difficulty making ends meet during Prohibition, even though both made attempts to operate as speakeasies—places where patrons gathered to drink illegal alcohol in dark silence. (Frank Pepe.)

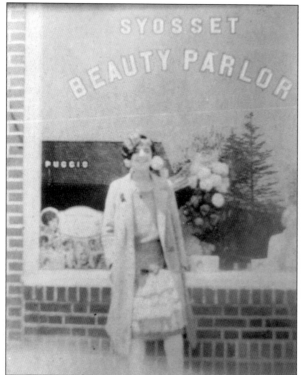

When it came to appearance, the estate wives spared no expense. Gaspar Puccio, the barber, had the good sense to recognize this as an opportunity to expand the Puccio family business. In 1926, he converted half his barbershop into a beauty salon for his 16-year-old daughter, Sadie. The Syosset Beauty Parlor had all the latest equipment for creating waves and permanents, and charged $1 for a haircut, shampoo, and manicure. Here, a proud Sadie Puccio poses in front of her newly opened establishment. (Rosaria Cuccino Glaser.)

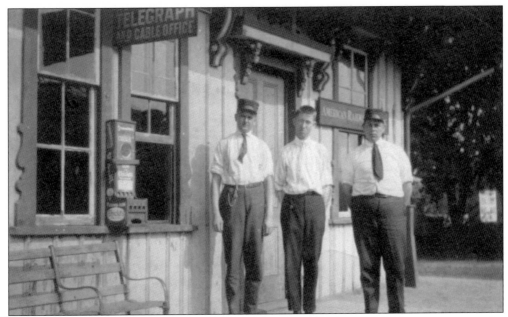

As the number of Syosset estates multiplied, activity at the Syosset train station once again increased. Businessmen needed to travel back and forth to the city almost on a daily basis and had come to rely on faster mail service via the railroad. In 1916, Floyd Jarvis became Syosset's new stationmaster, a position he held for 45 years. This 1919 photograph shows Jarvis flanked by crew members George Carnes and Albert Phesy in front of the station house. Note the Chicklets gum machine and the Western Union telegraph sign. (Henry Marzola.)

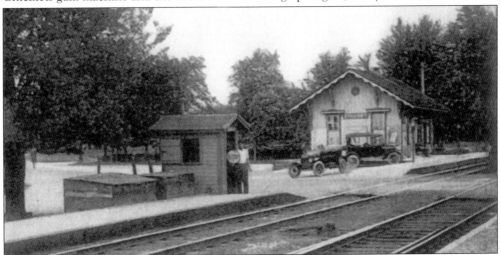

Floyd Jarvis's responsibilities included ticketing, decoding and delivery of telegraph messages, and coordination of mail services. Although the Long Island Rail Road's postal train did not stop in Syosset, the hamlet's mail was picked up and dropped off by a nonstop mail train that whizzed through the station once or twice a day. Jarvis was responsible for suspending Syosset's outgoing mail sack from a wooden pole by the side of the tracks, where he was required to meet the mail train to snatch the incoming bag. If he missed the train, he had the embarrassing task of explaining to irate residents why the important mail they were awaiting might be a little late. (Don Karas.)

Before Floyd Jarvis became Syosset's stationmaster, the position had belonged to a young man named Ralph Kaiser. Kaiser went on to become, perhaps, Syosset's best-known resident of the 20th century and was known to friends, neighbors, and acquaintances as "the Mayor." A simple, unassuming man, who happened to be a personal friend of Theodore Roosevelt, Kaiser was instrumental in bringing water, gas, lights, and garbage collection to Syosset, and in securing Works Progress Administration (WPA) grants that put unemployed Syosset men to work during the Depression. He also helped form Syosset's first chamber of commerce in 1915 and its first school board in the 1920s. This 1960s Christmas card sketch shows the Kaiser house, built in 1825, at the corner of Jackson and Devine Avenues. (Ruth Odwazny.)

Until the early 1920s, most of the water used by residents was collected from the roof and stored in a tank, or cistern, where it was purified, using lime or salt. During a dry spell, homeowners typically had to wash their clothes, clean the dog, and irrigate the garden with the same bucket of water. The wealthier estate owners could afford to have their own wells dug by contractors such as Norman Harris, whose equipment is shown here c. 1920 just north of the railroad station. In 1923, the newly formed Jericho Water District began to lay out Syosset's first piped water system. (Nell Boslet.)

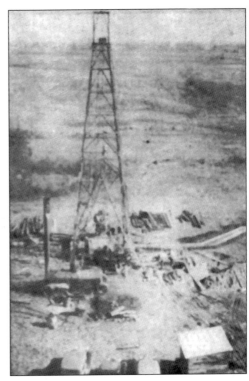

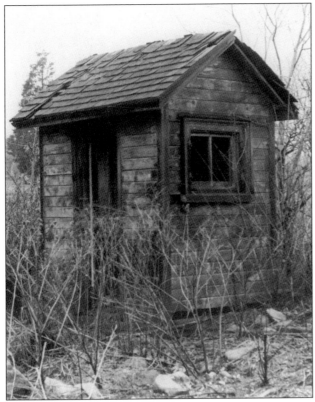

Syosset had some brutally cold winters over the years. Imagine having to get ready for school or work in this unheated wooden outhouse, photographed on the former Underhill property in 1970. Before the 1930s, just about every home, with the exception of the large estates, had an outhouse like this one. When internal plumbing became available, hooking up quickly became a priority. (Nassau County Museum, Long Island Studies Institute.)

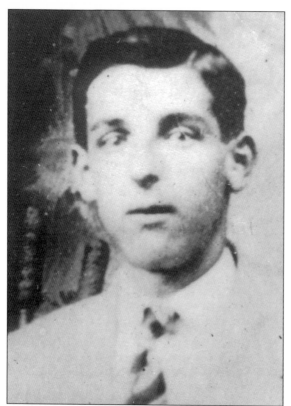

In April 1917, the United States was drawn into World War I by a German declaration of unrestricted submarine warfare against British shipping vessels. One year later, 30-year-old Eugene S. Smith of Syosset enlisted in the U.S. Army. Within three weeks, Smith's company was shipped to France to confront the German military in one of the decisive battles of the war. Although the mission was successful, Smith was captured by the Germans one day after the battle. On October 20, 1918, he died in a German prisoner-of-war hospital. (American Legion Post 175.)

Syosset's American Legion Post 175 was dedicated in honor of Eugene S. Smith in 1919.

Five

FIRE!

Throughout its history, the Syosset Volunteer Fire Department has earned numerous accolades for its performance and its dedication to the community. Its members, including several generations of founding families, such as the McInnes's, the Smiths, the Hendricksons, and others, have demonstrated remarkable skill and dedication in the most challenging situations. The history of the Syosset Fire Department is worthy of a book of its own but, as a primer, here is the story of the organization's early days.

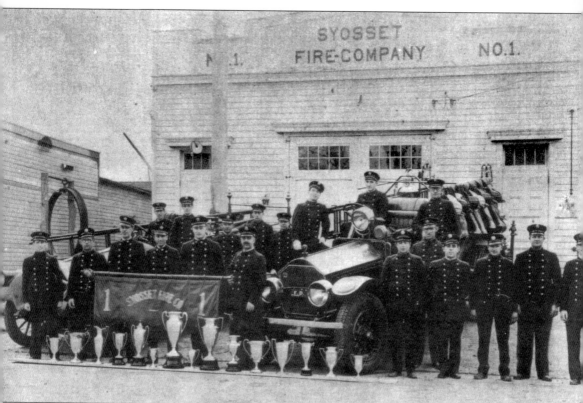

Prior to 1915, a Syosset property owner's best defense against a fire was a good supply of well or pond water and a sizeable gang of loyal friends. Beyond that, if a fire were more serious, the property owner had to rely on organized fire departments from Hicksville or Oyster Bay. A 1915 fire that completely destroyed a house in the center of town prompted a group of civic-minded residents to organize a volunteer fire company right in Syosset. They sent handwritten letters to every resident, asking for contributions and organized various fund-raisers to purchase water buckets and other equipment. Fire Company No. 1 got its first call in December 1915, when a house near the railroad station went up in flames. Members, summoned by a shotgun blast, met at Gus Kleiss's blacksmith shop to grab their buckets and run to the scene of the inferno. Next, they formed a bucket brigade, passing buckets of water from one volunteer to another, beginning at a well or pond somewhere in the vicinity. The men at the front of the line then doused the flames with bucket after bucket of water until, eventually, the fire was extinguished. Then, the men all returned to their regular jobs. Included in this c. 1918 photograph are James Devine, Henry Weirshowsky, Anthony Puccio, James McInnes Jr., William Schmidt, Gaspar Puccio, William Rynsky, William Knettel, Gus Kleiss, Harold Allen, and Burleigh Horan. (Henry Marzola, Syosset Fire Department.)

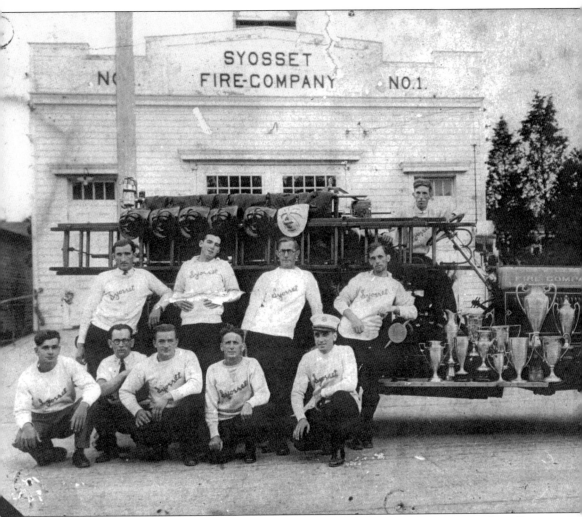

The bucket brigade was extremely inefficient, since fires did not always occur near ponds, wells, or cisterns and there was no way to store water on the first fire trucks. In 1916, the fire company raised $3,650 to buy a truck with two 40-gallon tanks, which could be filled ahead of time and used to fill the buckets when a fire broke out. The members also built their own firehouse at 35 Muttontown Road, shown here as the backdrop to the Syosset Fire Department's 1929 Championship Motor Pump Racing Team. Shown, from left to right, are the following: (front row) Walter Weirshowsky, Henry Weirshowsky, William Rynsky, James A. Devine, and James McInnes Jr; (back row) Dennis Volovmich, Burleigh Horan, Horace Allen, and Leslie Beaumont. Clarence "Dunk" Smith is at the wheel. (Syosset Fire Department.)

RECAPITULATION.

RECEIPTS.

Total contributed - - - - - -	$2,733.00	
Raised by entertainments, etc. - - -	1,229.61	
Dues collected - - - - -	165.99	
Interest on deposits - - - - -	2.67	$4,131.27
Mortgage loan - - - - - -	1,500.00	$5,631.27

DISBURSEMENTS.

Cost of Fire House - - - - -	$2,230.88	
Paid on Auto Fire Truck - - -	2,045.56	
Cost of Lot - - - - - -	300.00	
Insurance on Auto Fire Truck - -	139.11	
Chairs - - - - - - -	81.15	
Fuel, Light and Janitor - - - -	79.94	
Printing, etc. - - - - - -	16.35	
Incorporation Tax - - - - -	4.50	
Badges - - - - - - -	32.00	
Chemicals, Gasoline, etc. - - -	74.55	5,004.04

Balance on hand February 1st, 1917 - $ 627.23

PENDING OBLIGATIONS.

Indebtedness on Auto Fire Truck;

Principal of note for $537.50, with six months' interest, due February 28th, 1917.

Principal of note for $537.50, with nine months' interest, due May 28th, 1917.

Principal of note for $537.50, with twelve months' interest, due August 28th, 1917.

Indebtedness on Fire House;

Mortgage - - - - - - - - - $1,500.00

Respectfully submitted,

SYOSSET FIRE COMPANY No. 1.

Syosset, N. Y., Feb. 1st, 1917.

The first annual report of Syosset Fire Company No. 1 shows financial progress from the company's inception on November 29, 1915, to February 1, 1917. Contributors during the first year included T. Ashley Sparks (one of the most generous at $100), the Jacksons, the Underhills, the Van Sises, the Langs, and W. Emlen Roosevelt. In later years, financial support increased as Syosset's population grew and the need for fire protection became more evident. (Elizabeth Williams Reynolds.)

Telephones were still new to Syosset in the early 1900s; the closest one to the fire station was in Gaspar Puccio's barbershop, near the corner of Jackson Avenue and Muttontown Road. It was here that first word of a fire was usually received. Syosset's first official fire bell was an old steel locomotive wheel suspended on a wooden rack. In those days, the striking of the bell with a metal rod could be heard for miles around. The original bell was later displayed outside the firehouse on Cold Spring Road.

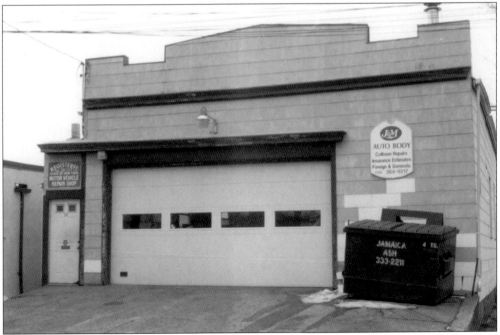

The original firehouse was still in use as an auto body shop 85 years after it was built.

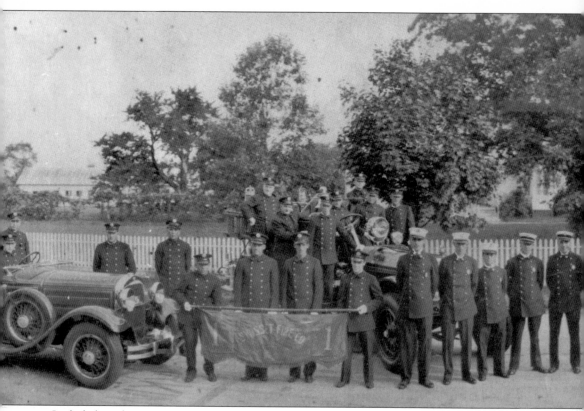

Included in this *c.* 1938 photograph of Fire Company No. 1 and Hook & Ladder Company No. 1 at the corner of Muttontown and Split Rock Roads are Chief James McInnes Sr., Anthony Puccio, James Devine, Burleigh Horan, and Theodore V. Summers. The 1931 Model

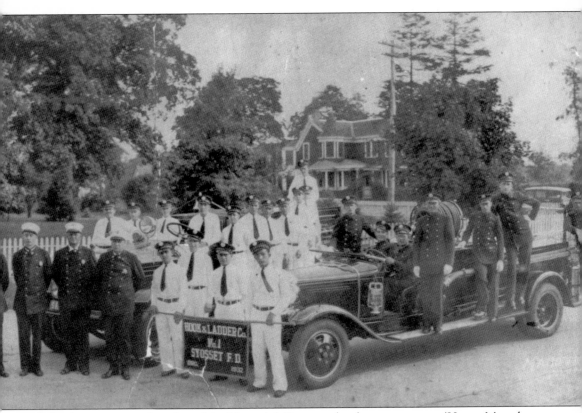

A Ford was preserved and used in Memorial Day parades for many years. (Henry Marzola, Syosset Fire Department.)

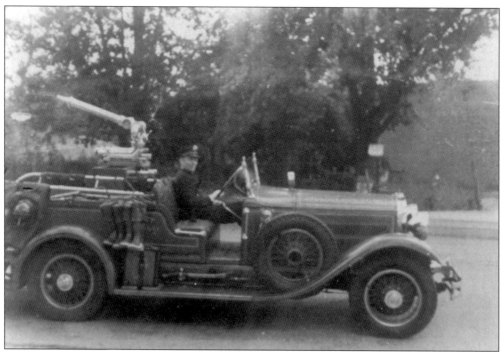

These are two of Syosset's early fire trucks from the 1930s and 1940s. In 1927, residents voted to form a Syosset Fire District. From then on, the fire company was supplemented by tax money instead of private donations alone. The fire equipment used in the 1930s and 1940s still had to carry its own water, as fire hydrants were not installed in Syosset until the early 1950s. (Syosset Fire Department, Alan Boslet.)

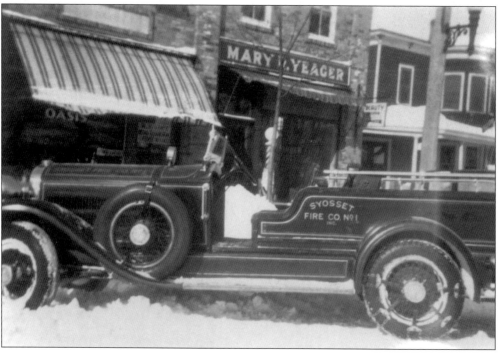

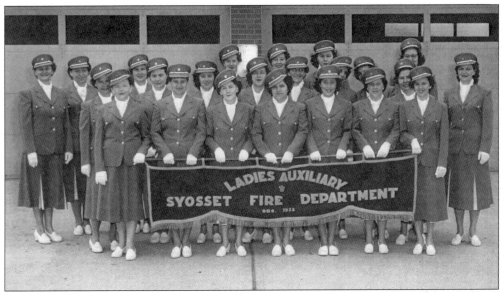

Syosset's vulnerability to enemy air strikes during World War II (several defense plants operated here during the war) convinced local residents and department officials that expanded fire and emergency protection was needed. During the war in Europe and the ensuing Cold War with the Soviet Union, the fire department purchased several new trucks and other pieces of equipment and began making plans for a new, larger firehouse on Cold Spring Road. Here, the 1956 Ladies' Auxiliary poses in front of the Cold Spring Road firehouse, which opened in 1952, the same year an additional firehouse was built on Woodbury Road. A third firehouse was built on South Oyster Bay Road in 1958. (Syosset Fire Department.)

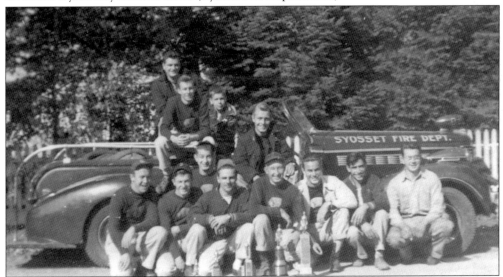

The Syosset Fire Department tournament team poses for a victory photograph after winning the New York State Pump Record in 1949. Shown, from left to right, are the following: (front row) Joe Miron, Ed "Snap" Miron, Bob Brutsch, John "Smitty" Smith, Joe Hoda, Bob Middendorf, and Henry "Muzzy" Marzola; (back row) Tom Garvey, Jim "Mootsie" Thomas, Stan "Little Cement" Kwiatkowsky, and George Allison (seated at the wheel). (Henry Marzola, Syosset Fire Department.)

Although crime was not a major issue in Syosset in the 1920s, the continuing influx of wealthy families raised the likelihood of robberies and break-ins. In 1926, Nassau County set up this police precinct house on Muttontown Road within a short distance of some of the largest estates. The precinct house is shown in 1931. (Nassau County Police Museum.)

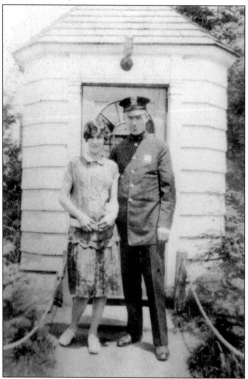

The following year, the county constructed a small police booth on the west side of Jackson Avenue, with an unobstructed view of the newly founded Syosset Bank. Electric streetlights were also installed along Jackson Avenue the same year. Here, the town officer poses with one of the locals. Police officers considered assignment to Syosset punishment duty, as Syosset was such a quiet, humdrum town. (Rosaria Cuccino Glaser.)

Six

SCHOOLS AND
RECREATION

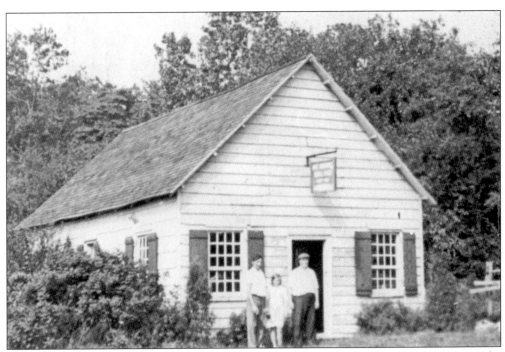

The Syosset-Woodbury school system has come a long way from its humble beginnings. The earliest school in the area for which written records have survived is the *c.* 1748 one-room Woodbury School, at the corner of Woodbury Road and Jericho Turnpike. The building contained a fireplace which, during the summer, served as a dark closet for punishing disobedient pupils. This photograph was taken in the early 1930s, after the building had been sold for $18 and moved to a private estate. (Syosset Public Library Local History Room.)

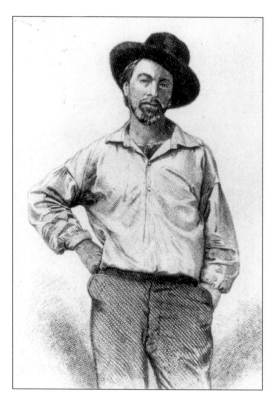

The Woodbury School is probably best known for its most famous teacher, the poet Walt Whitman, who had a brief, unsuccessful teaching stint here in 1840. In a letter to a friend, the 21-year-old Whitman referred to Woodbury's residents as "coarse gumpheads," "contemptible ninnies," and "country bumpkins." The students, he said, were "dirty, ill-favored young brats." Whitman was dismissed after just one term. (Walt Whitman Birthplace Association.)

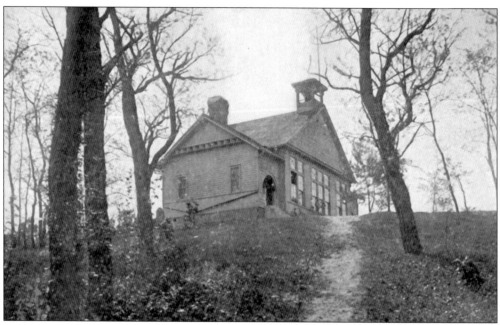

As Woodbury's "country bumpkins" multiplied, they needed a more spacious place to learn. In the early 1900s, this larger, two-room structure replaced the original Woodbury schoolhouse. The new school had a hand well, a pump, and two outhouses in the back. A single teacher taught all 25 to 30 children in grades one through eight. (Carl Baker.)

In 1927, the second schoolhouse was replaced with this more modern brick building. Two years later, on the eve of the Depression, 24-year-old Harry B. Thompson took over as the Woodbury School's principal. When rough economic times fell upon the area, Thompson kept the school open seven nights a week to provide recreation, counseling, and job search assistance for the children. H.B. Thompson served as principal for 30 years and was eventually honored with a middle school in his name.

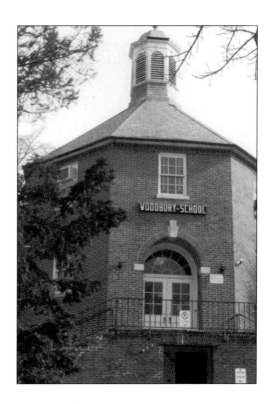

Another local man who spent a good amount of time at the Woodbury School was James Irving Baylis, who owned a general store about a half-mile north on Woodbury Road. During the Depression, Baylis always made sure the children had fruit, bread, and enough coal to keep warm during winter blizzards. Like H.B. Thompson, J. Irving Baylis also eventually had a school named after him. The brick Woodbury School, photographed in 2001, was later used by the Syosset Central School District as a printing and storage facility. (Nassau County Museum, Long Island Studies Institute.)

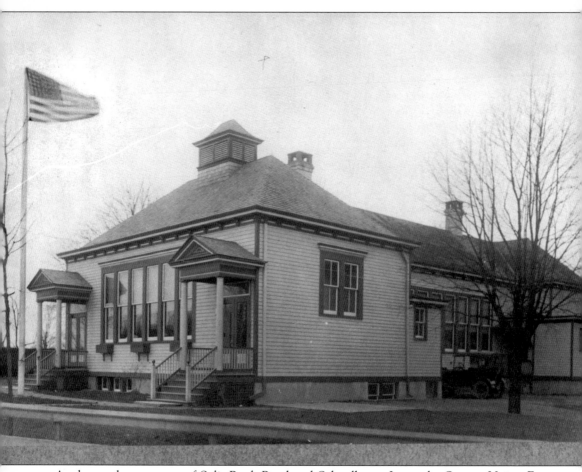

At the southeast corner of Split Rock Road and Schoolhouse Lane, the Syosset Union Free School, also known as Split Rock School, had been in operation since at least 1880, when Marie DuMont was in charge of 45 youngsters aged 5 to 17. The original one-room schoolhouse was replaced *c.* 1905 with this two-room wooden building, photographed *c.* 1920. A pot-bellied stove provided heat in the winter, and children hauled buckets of water from local ponds for washing, drinking, and outhouse use. (Syosset Public Library Local History Room.)

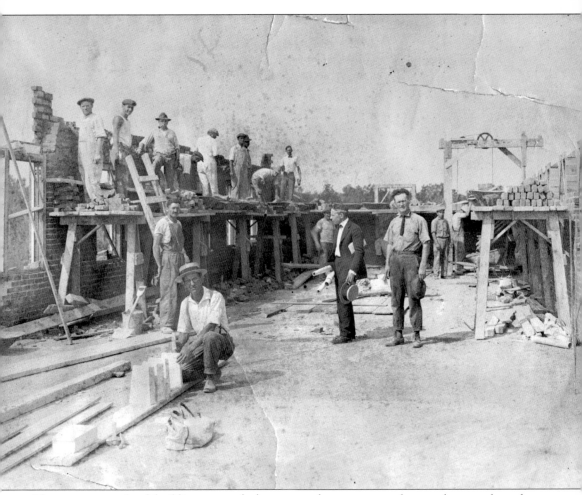

The two-room school building was only large enough to accommodate grades one through eight. Students in the upper grades attended schools in Hicksville or Oyster Bay, as Syosset did not build its own high school until 1956. By 1923, enrollment at the Syosset school had reached 114, and the two-room building was no longer sufficient. The fire department provided additional space in the Muttontown Road firehouse for some time, but that solution quickly became impractical. In 1925, the Syosset School Board purchased four and a half acres adjacent to the original school and hired an architect to design a new fireproof brick schoolhouse. Here, workers begin construction the same year.

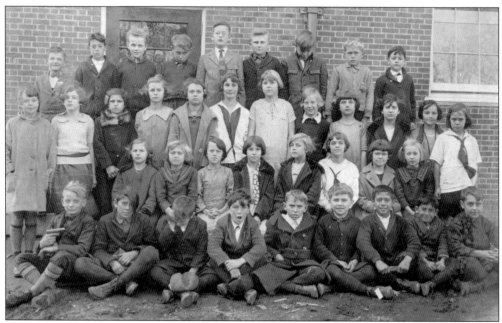

This 1925 photograph of the Syosset School's fourth- and fifth-grade classes includes almost as many students as were enrolled in the entire school 45 years earlier. The boy with the water gun in the first row is Gus Kleiss Jr., son of the blacksmith. (Nellie Solnick.)

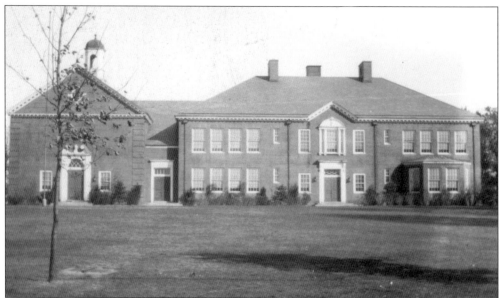

The new Syosset School, built at a cost of approximately $230,000, had 10 classrooms, an auditorium, outdoor playground, and, much to the students' delight, indoor bathrooms. According to official records, the school's first Bible and American flag were donated by the Ku Klux Klan, which had a strong membership on Long Island during the 1920s. (Nassau County Museum, Long Island Studies Institute.)

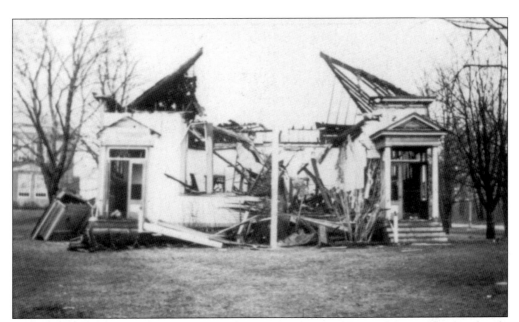

Unfortunately, the original wooden schoolhouse, shown in 1935, was destroyed by fire shortly after the new school was built. (Dorothy Van Sise Suydam.)

In 1935, 24-year-old Frank Manarel became the Syosset School's first male principal, beginning a 30-year career as one of Syosset's most beloved educational figures. Shown here with his wife, Bette Manarel, in the early 1960s, he not only brought school spirit and self-esteem to the students but also went on to play a major role in the emergence of Syosset as an award-winning school district. Bette Manarel was also a much admired educator who taught Syosset's first class for learning-disabled children. (Bette Manarel.)

61

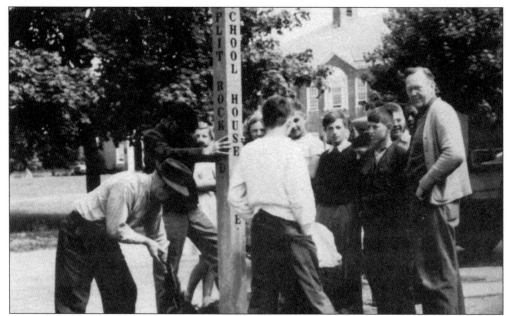

A real "kids' man," Frank Manarel organized various student projects, including the installation of handmade street signs on Split Rock Road in 1935, 15 years before official street signs were installed. On the left is custodian Carl Carlson. On the right is teacher (later principal) Wilson Gearhardt. Frank Manarel is noticeably absent. Perhaps he was taking the picture. (Judith Manarel Plant.)

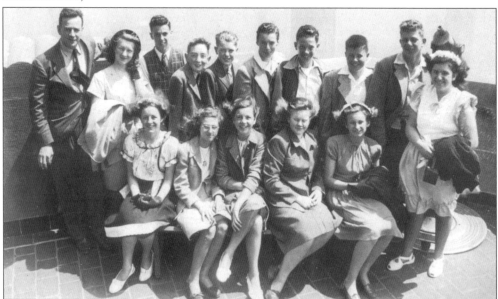

Manarel's great accomplishments at the Syosset School included an annual Halloween party aimed at curbing Halloween Night mischief. If October 31 was quiet and trouble-free around the neighborhood, Manarel rewarded the children with a day off from school. Fifth-grade classes, like the one pictured in the mid-1940s, also looked forward to Manarel's annual class outing to the Empire State Building in Manhattan, a world away for Syosset students. (Bette Manarel.)

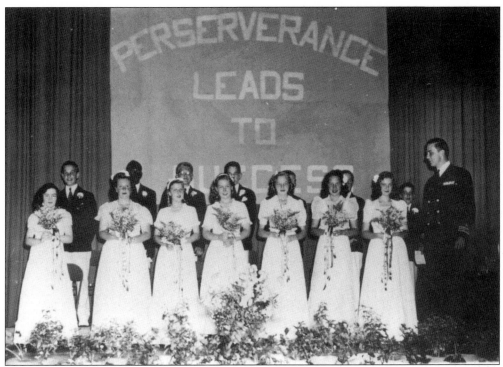

The Syosset School's graduating class of 1944 had a real treat when the guest of honor at their graduation ceremony was none other than Franklin Delano Roosevelt Jr., son of the president of the United States. FDR Jr.'s words of wisdom included "Perseverance leads to success," the school's motto for that year. Members of the class later quipped that there were more secret service agents at the 1944 graduation than there were students. (Frank Pepe and Lillian MacDonald Pepe.)

Much to the dismay of former students and longtime residents, the Split Rock School was demolished in 1984 to make way for a residential development. These houses, lining the sidewalk along Split Rock Road, now stand where generations of children learned to read and write.

Another major figure in the early days of the Syosset-Woodbury Schools was Elisabeth Babcock, who began her involvement with the school board in 1924. An assertive woman with a strong set of moral values, she went nose-to-nose with the board on many critical issues during her 47 years as a member and then president. Along with Frank Manarel, she also played a key role in the centralization of the school district in the 1950s. (Syosset High School Yearbook, 1968.)

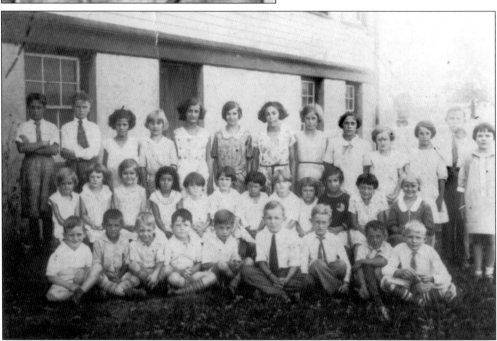

A third school, for which no official records have survived, existed in the early part of the 20th century on the west side of South Oyster Bay Road, near present-day James Street. The original wooden Locust Grove School was named for the section of town in which it stood. (Cassie Manelski.)

Students remember nicknaming the first Locust Grove School "Frog College," perhaps because the teacher's name was Miss Fish. Young male students from the 1920s and 1930s remember being hollered at in the early days of the school term for making too much of a swishing noise with their new corduroy pants. Fortunately, by midyear, the corduroy had worn down enough so that the swishing ceased and so did the scolding. Girls were not allowed to wear slacks, lipstick, or any kind of make-up back in 1932, when this photograph was taken. (Cassie Manelski.)

In 1932–1933, a brand new Locust Grove School was built across Jericho Turnpike on Humphrey Drive. The construction of this school and the adjacent water basin provided an excellent opportunity for sand miners who, in the course of their digging, unearthed numerous Native American artifacts that told much about the area's earlier days. The Locust Grove School closed in the late 1970s and was taken over by a center for children with learning disabilities. (Frank O'Hagan.)

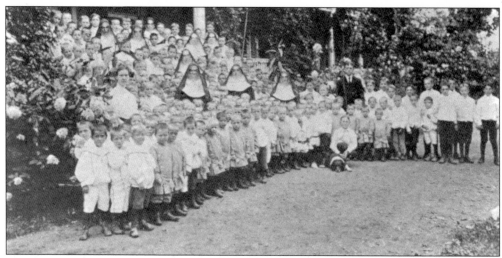

The late 1800s were desperate times for the needy. Orphaned children frequently ended up in poorly managed public housing, where they suffered untold abuse and were denied an education. In 1893, the Sisters of Mercy purchased 120 acres of the Van Nostrand farm on today's Convent Road and, one year later, established St. Mary of the Angels Home, a residence and school for approximately 175 orphans. This photograph was taken *c.* 1924. (Carl Baker.)

Seven St. Mary's boys pose for a graduation photograph in their best knickers outfits *c.* 1920s. Two of St. Mary's most notable features in the early 1900s were its large bronze bell, which could be heard throughout the downtown area each day at noon and 6:00 p.m., and its farm, which 1908 resident Francis Spearman later recalled, ". . . was a complete farm. We, as summer arrived, helped in the many little tasks—the chickens, the gathering of the eggs, feeding the pigs . . . As we matured, we got our own little garden patch, prepared the soil to plant, to pick, and yes, to eat . . . In the St. Mary's of my day, we all played together, fought together, shared our hurts, our gifts, and, at times, cried together. And it was good." (St. Mary's Children & Family Services.)

Our Lady of Mercy Academy, originally a boarding school for 63 girls from grades 1 through 12, was built in 1928 on unused property owned by St. Mary of the Angels at the easternmost end of Convent Road. Eventually, in the 1950s and 1960s, the lower grades were eliminated and Our Lady Of Mercy became exclusively a senior high school. (Syosset Public Library Local History Room.)

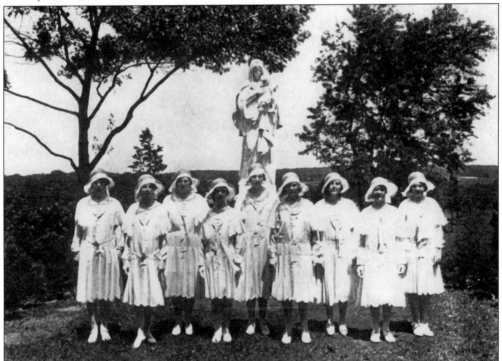

These women are members of the graduating class of 1930 at Our Lady of Mercy Academy. The all-girls school went on to win several Excellence in Education awards, as well as other accolades in the years ahead. (Syosset Public Library Local History Room.)

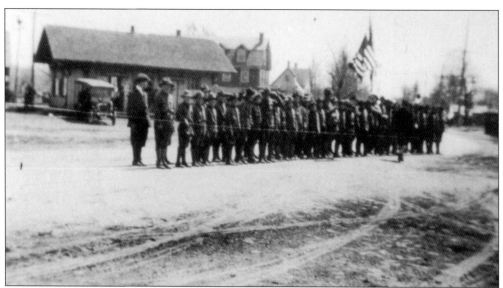

The Boy Scouts of America was a popular activity among Syosset youths in the 1920s and beyond. Here, the local troop assembles on Jackson Avenue c. 1926. Notice the combination of tire marks and horseshoe prints on the road's dirt surface. (Alan Boslet.)

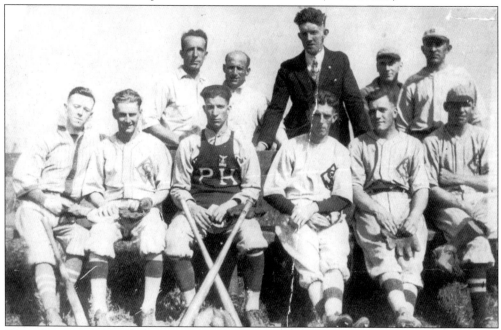

Even Syosset's "older kids," those in their twenties and thirties, needed time to play. Baseball was especially popular in the second decade of the 20th century, when the Syosset Federals began playing organized, semiprofessional games at Summer's Field, on Berry Hill Road between the present-day North Street and Church Street. Residents gathered along the baseline to watch the Federals take on teams from other towns while friends passed a collection hat to help support the team's travel expenses, uniforms, and other costs. This c. 1919 photograph includes Harry Watson, Bert Smith, Doc Melville, and Clarence Watson. (Stanley Summers.)

Seven

FARMS AND THE GREAT DEPRESSION

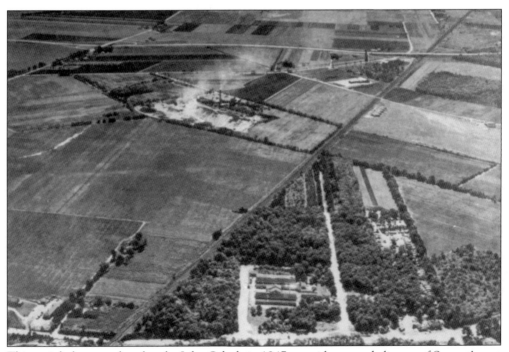

This aerial photograph, taken by John Schulz in 1947, provides a good glimpse of Syosset's vast acres of farmland. In the earliest days of Long Island, settlers were lured to places like Syosset by the Dutch West India Company's promise of free property to any pioneer who would cultivate the land for them. Thus began a long tradition of farming in this area that lasted more than 300 years. The following photographs provide an overview of Syosset's farming history during the first half of the 20th century.

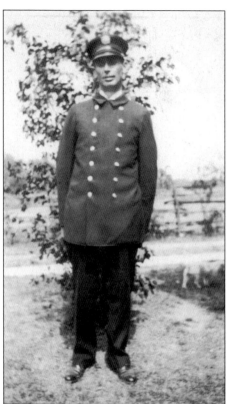

Eugene Williams, photographed in his Syosset Fire Department uniform in the early 1920s, began working on his father's farm as a young boy. William Williams had purchased the property, which stretched along both sides of Jackson Avenue from Teibrook Avenue north to Convent Road and east to the Village School, in 1906. After leasing the property to the Devine family until 1913, Williams moved in and began growing potatoes, corn, string beans, and other crops. Sometime during the 1930s, Eugene assumed responsibility for the family farm and the Williams property holdings, all while serving as Syosset's Fire Commissioner. (Elizabeth Williams Reynolds.)

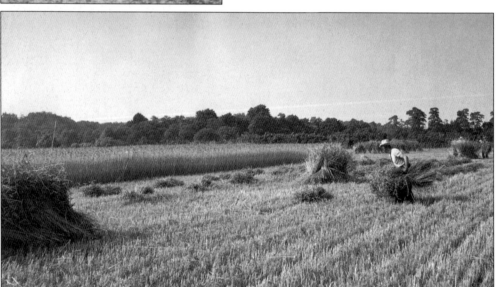

Eugene Williams gathers hay along Jackson Avenue in the 1940s. During World War II, the U.S. Army assigned German prisoners to work on the Williams farm. Each day, a young German POW, accompanied by an armed guard, arrived with a small sandwich, a bottle of soda, and an orange—hardly enough to sustain even the healthiest young laborer in the hot field for a day. To supplement the POW's ration, Emily Williams often prepared an extra portion of stew or a heaping mound of mashed potatoes. (Elizabeth Williams Reynolds.)

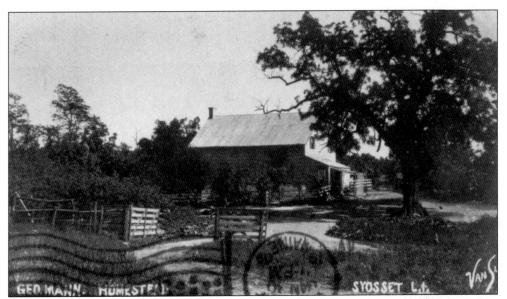

For the first half of the 20th century, more than 115 acres along Convent Road belonged to George Mann, another of Syosset's hardworking farmers. The farm sat on a fairly steep hillside that farmer Mann let children use for sleigh riding in the winter, and on which the Village School was later built. This *c.* 1909 postcard view shows the Mann family's modest homestead. (Carl Baker.)

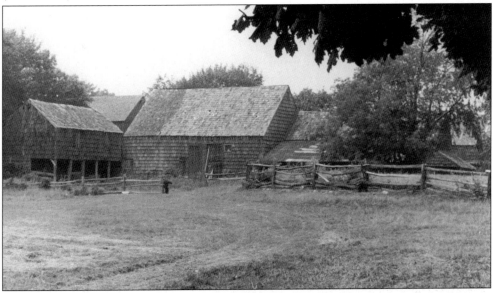

Descendants of the legendary Capt. John Underhill, Harry and Arthur Underhill were born on a Jericho Turnpike farm in the late 1800s. In 1919, their parents, Stephen and Henrietta (Willis) Underhill, inherited the massive Willis Farm in Syosset. At first, the couple grew cucumbers and cabbage for the McGuire Pickle Factory, but when the factory closed down, they moved on to potatoes, corn, tomatoes, and more. Eventually the two brothers took over the farm, which continued to thrive into the mid-1950s. This Underhill barn was photographed *c.* 1970, just before it was moved to the Old Bethpage Village Restoration. (Nassau County Museum, Long Island Studies Institute.)

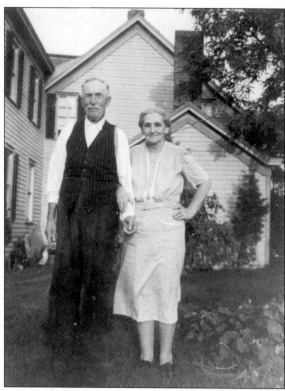

The Horan family cultivated a good deal of property east of the curve at Cold Spring Road beginning in the 1890s, when Michael Horan and his wife, Mary Horan (photographed c. the late 1940s), established Pleasantview Farms. (Lorel Horan Repetti.)

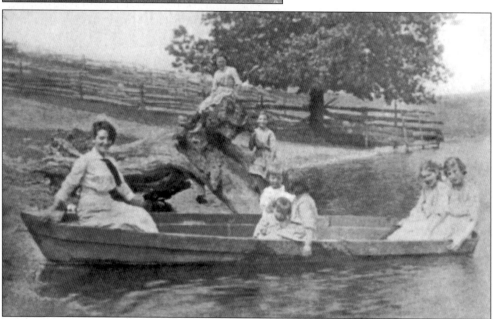

One of the young Horans' favorite summer pastimes was swimming and boating on Pelican Pond, which was part of Michael Horan's property. According to Cecilia Horan, shown atop the tree stump in this 1913 photograph, the real Pelican Pond was farther northeast than the pond later called by that name, at the corner of Cold Spring Road and Syosset-Woodbury Road. (Cecilia Horan Kreutzer.)

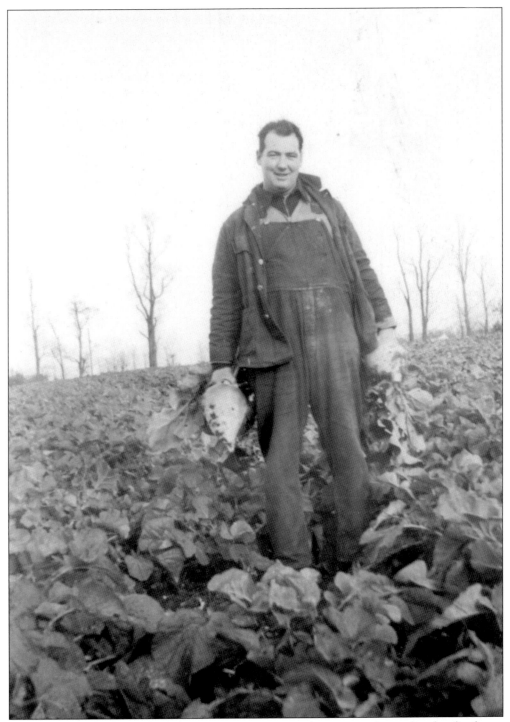

Michael Horan's son, Burleigh Horan, spent several years working the family farms, earning a reputation around town as the "Corn King." Various other Horans also farmed in Syosset over the years. Here, Burleigh Horan takes a break from picking turnips in 1942. (Lorel Horan Repetti.)

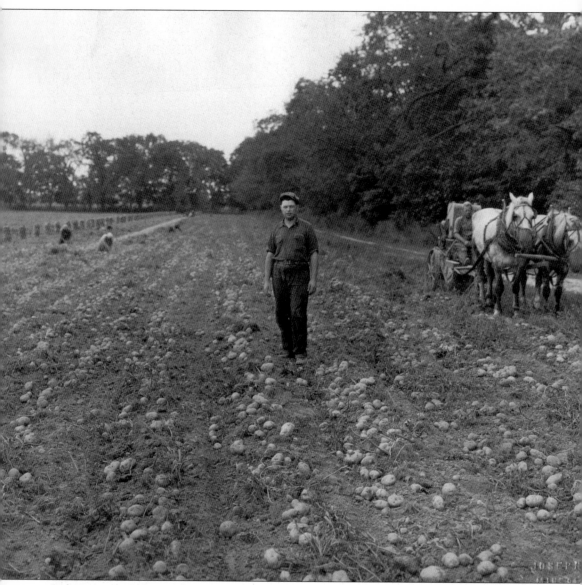

Before major residential development began in the 1950s, the Woodbury area, as well as the southern end of Syosset, was virtually all farmland owned by families with names such as Kennedy, Meyers, Terrehans, Hicks, Keibel, Van Sise, and Froehlich. For generations, these families produced some of Long Island's finest potatoes, corn, and other vegetables. One of Woodbury's most successful farmers was John Froehlich Jr., shown in his potato field on Woodbury Road in 1941. Froehlich donated a sizable portion of this field to the Holy Name of Jesus Church in 1964. The remainder of the property was later developed as a corporate complex, through which Froehlich Farm Boulevard now runs. (Barbara Froehlich Beaney.)

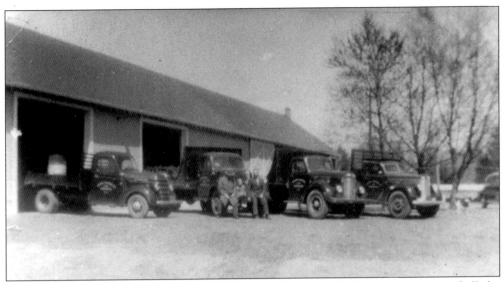

The Meyer farm on Woodbury Road, established in 1920, is the longest surviving of all the farms in the Syosset-Woodbury area. Like most farmers at the time, Peter Meyer secured a government contract to grow potatoes for the U.S. Army during World War II. Having sold 22 of his original 32 acres along Woodbury Road during the Great Depression, Meyer was grateful for the government's business. Above, from left to right, Peter Meyer Sr., Peter Meyer Jr., and Peter Meyer III pose with some of the Meyer farm vehicles *c.* 1950. (Meyer family.)

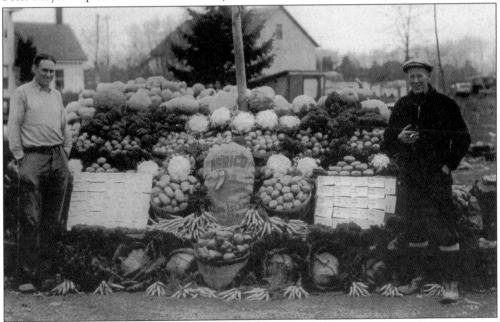

One of the earliest farming families in the Woodbury area was the Van Sise family, whose main parcel was at the corner of Southwoods Road and Jericho Turnpike. Sidney Van Sise (right) was a distant cousin of Charles Van Sise, who owned a general store on Berry Hill Road in Syosset. Along with his son, Harold Sise (left), he grew a wide variety of both common and unique vegetables and consistently took several top prizes in the annual Mineola Fair. Here, father and son proudly pose with a prizewinning display in the late 1930s. (Herbert Payne.)

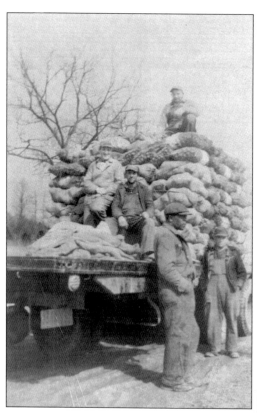

During the Great Depression, the typical farmworker's salary of between $2 and $2.50 a day was considered a blessing. This early-1950s photograph shows Herbert Payne in foreground with some unidentified Van Sise workers after loading a truck bound for market. (Herbert Payne.)

Survival during the Depression often meant putting every able-bodied family member to work. Depression-era children typically worked the fields for a couple of hours in the morning and then returned to the fields after school to work until dusk. Herbert Payne, one of Woodbury's earliest African American residents, went to work for the Van Sise family in 1927 at age 12, picking peas for 50¢ a bushel, a chore that could easily take three hours or more. (Herbert Payne.)

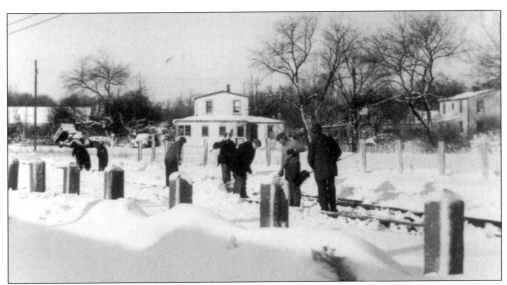

While Syosset's well-to-do estate owners lived it up in the 1920s, the farmers and other working-class residents were on the verge of economic disaster. By the end of the decade, an unprecedented economic depression enveloped the country, causing many to lose their farms, businesses, or homes. In the mid-1930s, Pres. Franklin Delano Roosevelt established the Works Projects Administration (WPA) to provide government-sponsored employment opportunities. The WPA put Syosset men to work performing odd jobs, including building sidewalks and clearing snow from the railroad tracks. (Alan Boslet.)

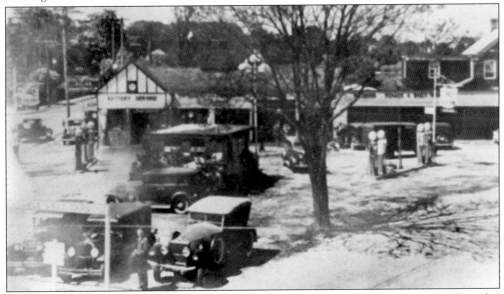

Interestingly, some Syosset businesses continued to flourish during the Depression, perhaps due to the increasing presence of old money in the area. The Syosset Garage, founded by Charles Krebs and John Schulz at the onset of Syosset's late-1920s automobile boom, quickly became one of the most bustling establishments in town, servicing both trucks for the local farmers and luxury vehicles for the estate owners. Photographed c. 1932, the garage stood in front of the old Lang Hotel, in which the Krebs and Schulz families lived during the Depression. (John Schulz Jr.)

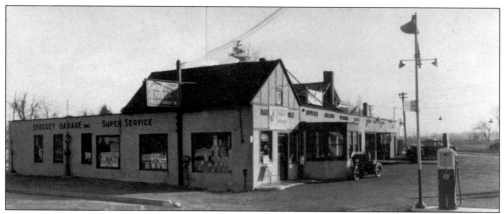

The Syosset Garage not only had fuel pumps but also several indoor bays where car owners could have their oil changed, brakes adjusted, and flat tires repaired. The full-service auto shop was still a unique concept in these early days of the automobile's popularity. This image is from the early 1930s. (John Schulz Jr.)

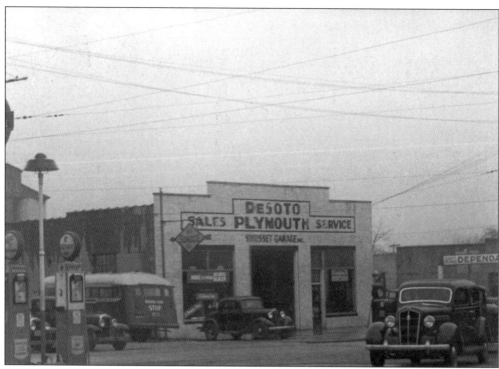

In a few years' time, Krebs and Schulz leased another building on the east side of Jackson Avenue and opened a small Plymouth-DeSoto dealership, shown in the mid-1930s. From here, they also started the K & S Bus Company and began transporting Syosset students to high school in Hicksville and Oyster Bay. (John Schulz Jr.)

Eventually, Krebs and Schulz purchased property at the corner of Whitney and Jackson Avenues on which to build a larger, more modern auto care center. This photograph shows construction under way *c.* 1937, just as the country's economic cloud was starting to lift. (John Schulz Jr.)

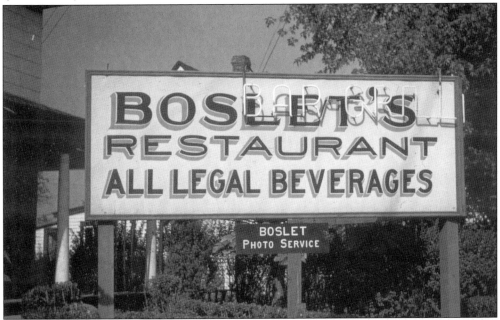

In the early 1930s, the U.S. Congress finally overturned the National Prohibition Act. Shortly afterward, Joseph G. Boslet became the new owner of the former Spreer's Inn, on Jackson Avenue, shown here in the late 1930s. Boslet's first order of business was to hang a sign outside the new Boslet Inn advertising "All Legal Liquor." Incidentally, the inn also housed the Boslet Photograph Service, which likely processed many of the photographs in this book. (Pamela Boslet Buskin.)

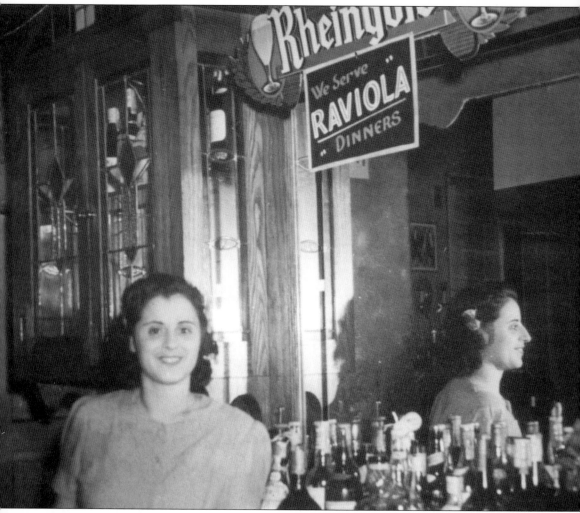

Italian food was still fairly new to Syosset in the early 1930s, when Gaspar and Josephine Puccio embarked on yet another business venture. Puccio's Tavern, located near the corner of Jackson Avenue and Muttontown Road, introduced many Syosset residents to "spaghetts," "manicotts," and even pizza. Here, Sadie Puccio poses behind the bar in the mid-1930s. Syosset customers must have loved those "raviola" dinners. (Rosaria Cuccino Glaser.)

Eight

The Railroad, Downtown, and the Turnpike

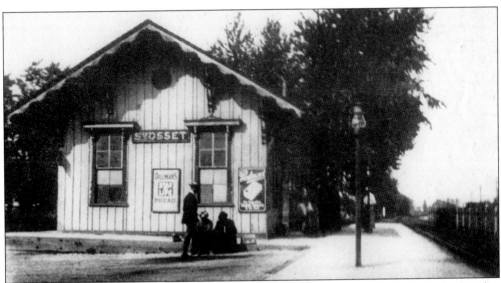

The Syosset railroad station, shown *c.* 1905, has always been a hub of activity in the hamlet. From its early days as a freight line for farmers to its transformation into a lifeline for business commuters, the railroad has facilitated tremendous growth in Syosset over the years. Ironically, in the 1870s, the LIRR could not even interest Syosset's 250 residents in raising $550 for a station house. Instead, this building was moved here from a closed station in Far Rockaway in 1877. (Robert Emery LIRR Collection, SUNY at Stony Brook.)

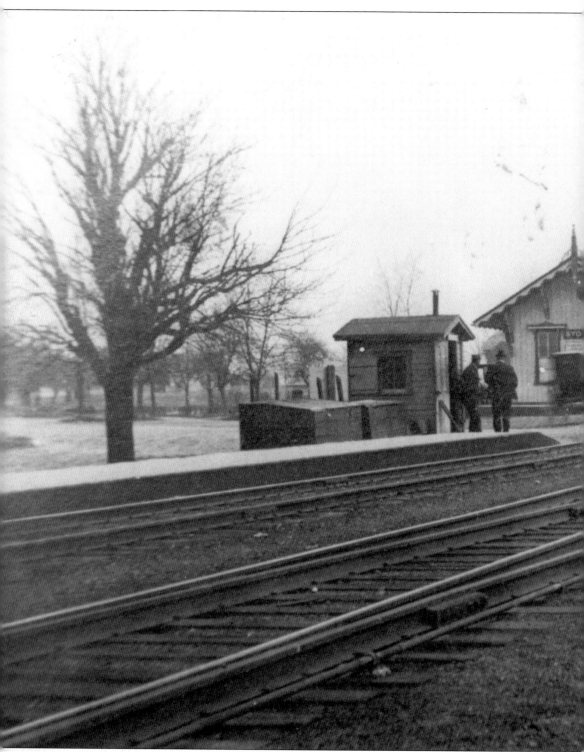

This panoramic station view from *c.* 1911 shows a two-man station crew awaiting the arrival of a train, an event which occurred rather infrequently in those days. Note the lack of

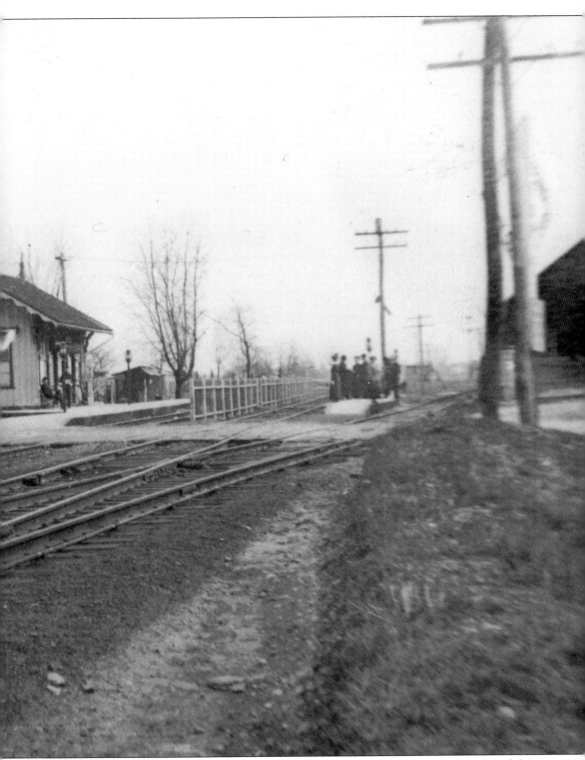

development along Jackson Avenue. To the right of the passenger platform is the edge of the McGuire Pickle Factory, which was operating at its peak at the time.

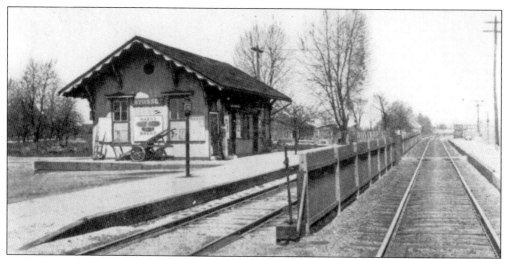

A closer view from a 1915 postcard includes some interesting features such as a mail cart, which the clerk used to transport mail between the station and the general store-post office. To the right of the cart is a scale used to weigh small freight prior to shipping. Also notice the light pole in front of the station house. Electric lights did not make it to Syosset until 1927. This light was powered by oil and was lit each evening by the stationmaster. (Carl Baker.)

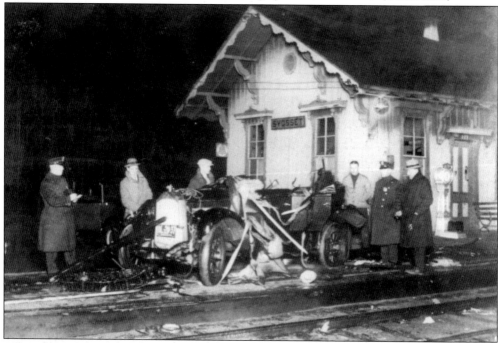

Even after automobiles became more prevalent in Syosset, the railroad remained a vital transportation link to the rest of the world. While there is no record of an auto-train collision on this date, this April 1926 file photograph from the Nassau County Police Archives symbolizes the new dangers of auto and railroad traffic sharing the same right of way. The increase in automobile traffic during the 1920s prompted the Long Island Rail Road to install manually operated warning gates at the Jackson Avenue crossing. (Nassau County Police Museum.)

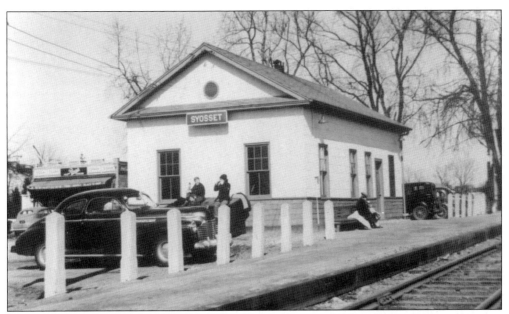

Before Krebs and Schulz started their school bus service in the late 1930s, Syosset teenagers used the railroad for daily transportation to Hicksville High School, which was quite a walk from the Hicksville station. A Saturday night date usually included a train ride to the Hicksville Movie Theater and, sometimes, a four-mile walk home along the tracks. In 1944, the 70-year-old station house (above) had its first major renovation, much to the distaste of those who admired the original Victorian roof. (Alan Boslet.)

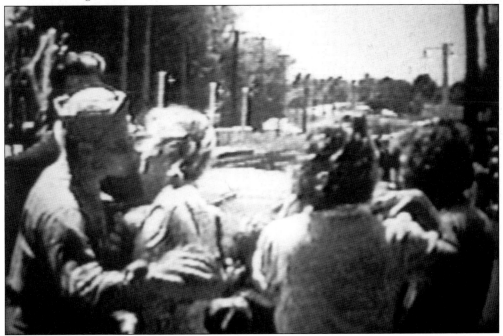

Syosset Station was also the scene of many teary goodbyes in the early 1940s, as hordes of young Syosset men bound for military duty in World War II waved goodbye to their families. (Raymond Smith.)

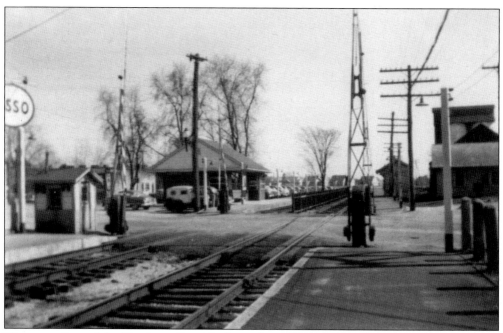

The extending of the Northern State Parkway from Westbury to South Oyster Bay Road in 1950 ushered in a whole new era of adventure for Syosset residents. Now they were free to explore places where the railroad did not go. From then on, the Syosset station was primarily the domain of business commuters and New York City theater-goers. Electric warning gates were installed in 1951, and the tracks were electrified in 1970. (Robert Emery LIRR Collection, SUNY at Stony Brook.)

Syosset's original downtown area was situated mainly on the west side of Jackson Avenue, shown at the left of this photograph from the mid-1930s. To the right of the utility pole, near the center of the photograph, is the Boslet Inn. To the left is Thomas Roulston's Grocery Store and Janke's Syosset Meat Market. (Carl Baker.)

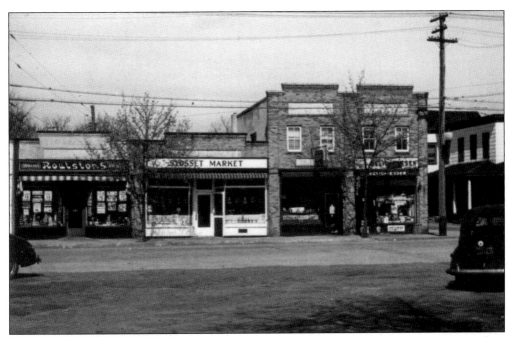

A closer look at a later date (1940) provides a clearer view of Roulston's, the Syosset Market, the Syosset Liquor Store, and the Syosset Delicatessen. These stores occupied property that is now part of the parking lot at 50 Jackson Avenue. (Carl Baker.)

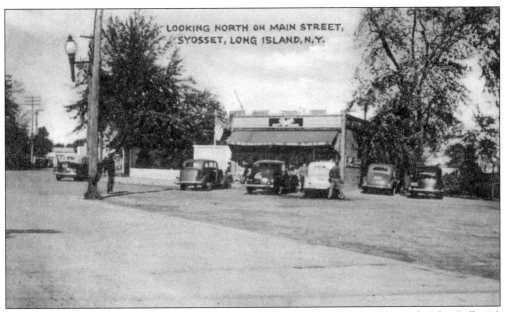

Across Jackson Avenue, on the east side of the street, Abe Weinstock's (formerly Jake Gelber's) newspaper store had a soda fountain that was very popular with the children during the 1920s and 1930s. When the New York Times started publishing a Sunday newspaper, Weinstock's was the only place in town to buy a copy, as most Syosset shop owners refused to sell newspapers on "the Lord's day." (Carl Baker.)

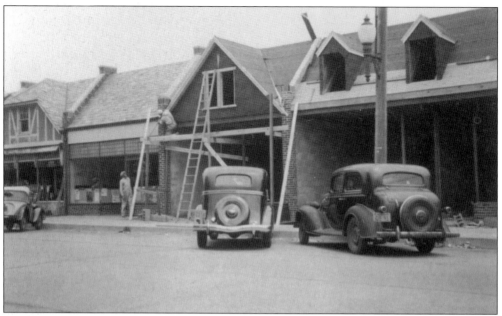

As the crippling effects of the Great Depression began to ease in the late 1930s, developer Henry Bermingham saw fit to expand the strip of stores along the east side of Jackson Avenue from just north of Weinstock's to the fork at Cold Spring Road. In this 1939 photograph, 47 Jackson is on the far left and No. 51 is on the far right. The worker on the sidewalk is standing in front of the newly opened Syosset Post Office, one of the first tenants of the east Jackson Avenue stores. (Alan Boslet.)

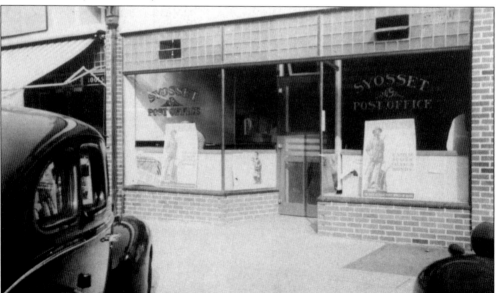

By the late 1930s, Split Rock, Berry Hill, and Muttontown Roads were lined with spectacular estates owned by businessmen for whom speedy postal service was an absolute necessity. During these years, the Syosset Post Office was finally given a home of its own in the new Jackson Avenue stores. The first postal storefront, shown here, was toward the south end, near the railroad station. (Pamela Boslet Buskin.)

In 1938, Gaspar Puccio decided to sell his barbershop and devote more time to the family's Italian restaurant. Before long, a gentleman named Fred Maimone walked into Puccio's shop and made him an offer. Within days, the two men struck a deal and Maimone was the new town barber. A year later, Maimone became the first commercial tenant in the new Bermingham stores, moving his shop into 51 Jackson Avenue, where his sign hung into the 21st century. The shop is shown in this late-1940s photograph. (Tony Maimone.)

Like father, like son. Anthony Maimone began working for his father in 1951. In the mid-1950s, Tony Maimone took over the responsibilities of Fred's Barbershop and began a nearly 50-year stint as one of Syosset's best-known and most beloved shopkeepers. Throughout his years as sole proprietor of Fred's, Tony Maimone epitomized the role of the small town barber, getting to know all of Syosset's most notable characters and accumulating a wealth of great Syosset stories. For many, one of Syosset's saddest days was the day Maimone finally sold the shop in 1999. (Tony Maimone.)

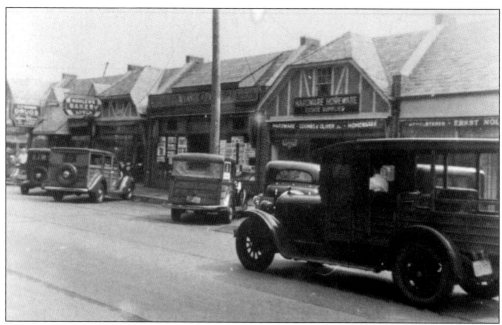

The basic facade of the Bermingham stores on Jackson Avenue has not changed much since this early-1940s photograph. Shops at the time included C.F. "Doc" Howard's Drug Store, Kohler's Bakery, the Atlantic & Pacific (A & P) Grocery Store, Coombs & Oliver Hardware, and Ernst Nolte's Upholstery Store. (Alan Boslet.)

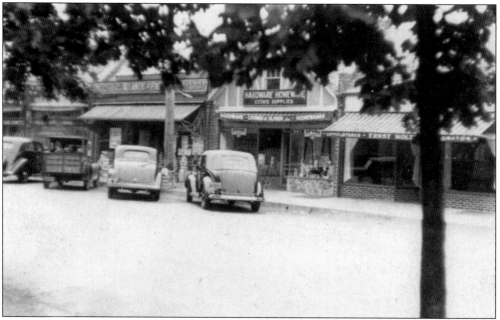

Perhaps the most unusual thing about this 1940s glimpse of the Jackson Avenue shops is the availability of parking spaces. During World War II, both gasoline and rubber were rationed, making automobile maintenance a bit of a hardship. Syosset residents from the 1930s and 1940s remember walking into town for most trips, always running into familiar faces, and sometimes spending hours chatting in front of the paper store. (Pamela Boslet Buskin.)

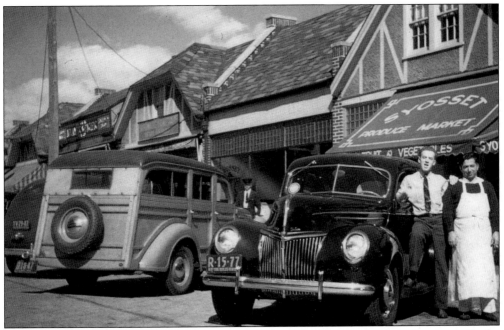

Before modern supermarkets, residents had to make a few extra stops to get all the ingredients for a home-cooked dinner. The A & P carried packaged and canned food, but did not sell meat or fresh produce. For these items, shoppers had to go to specialty stores such as Charlie Rella's Syosset Produce Market on Jackson Avenue, which always had a bountiful supply of fresh, locally grown vegetables. Here, Rella poses with an unidentified customer *c.* 1940. (Pamela Boslet Buskin.)

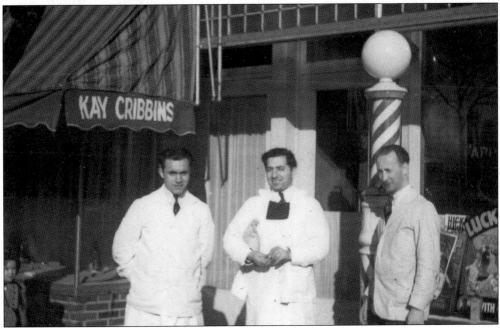

Danny Pepe, Charlie Rella, and Fred Maimone take a break for a photograph in front of Fred's Barbershop *c.* 1941. (Pamela Boslet Buskin.)

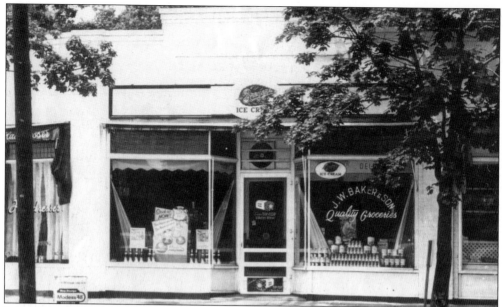

In the days before driving was common among women, most local grocery stores provided home delivery service. Carl Baker of J.W. Baker & Son once recalled how market owners engaged in friendly competition for who could charm the ladies best and, thus, win their delivery business. Similar competition existed for the business of the estate servants, who often expected kickbacks for placing their generous weekly orders. J.W. Baker & Son, established in 1949, was located on the west side of Jackson Avenue, a few doors down from Janke's Syosset Meat Market. (Carl Baker.)

Until the late 1940s, most local homes were heated with coal supplied by John Young's Syosset Coal, on Ira Road. A year's supply (six to seven tons) cost barely $100, including delivery. Because coal left thick, black soot in the basement, where it was delivered and stored, finished basements did not become a reality until the 1950s, when cleaner oil heat became more popular. (Syosset Tribune.)

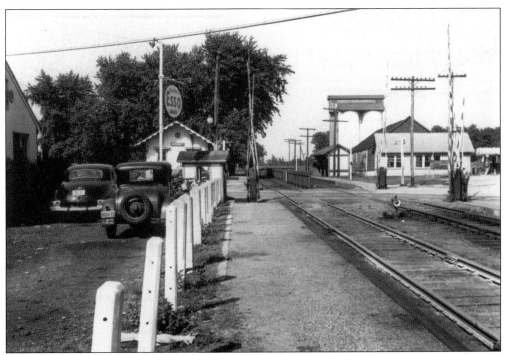

This early-1944 photograph looking east at the Syosset train station shows John Young's coal silos in what later became a parking lot for the railroad. The wooden building in front of the silos is part of the former pickle factory, which also belonged to Syosset Coal. (Art Huneke.)

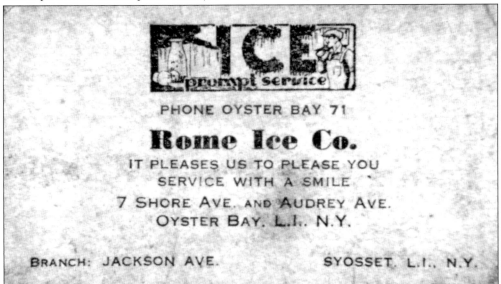

ICE
prompt service

PHONE OYSTER BAY 71

Rome Ice Co.

IT PLEASES US TO PLEASE YOU
SERVICE WITH A SMILE

7 SHORE AVE. AND AUDREY AVE.
OYSTER BAY. L.I.. N.Y.

BRANCH: JACKSON AVE. SYOSSET, L.I., N.Y.

Ice was also big business in Syosset during the first half of the 20th century. Homes were equipped with an icebox, which stored a block of ice provided by an enterprise such as the Rome Ice Company of Oyster Bay. Perishables were kept fresh in the icebox for several days, as the ice melted into a pan below. Emptying the pan was usually the responsibility of one of the children. If he or she forgot, the water might spill over into the basement—not a big deal, as the basement was already a mess from all the coal dust.

Jericho Turnpike, an old Native American path that early settlers called the Cartway Road, was a principal route of travel on Long Island well into the mid-1900s. As early as the 1700s, English and Dutch settlers used the turnpike to travel to the areas now known as Jericho, Westbury, Mineola, and beyond. Diaries from this era reveal that the turnpike was a haven for roadside bandits, a route which warranted traveling in caravans for protection. In 1810, the road was taken over by the Brooklyn, Jamaica, and Flatbush Turnpike Company, which smoothed the dirt surface somewhat, added wooden planks in areas prone to flooding, and built fences for various stretches along the way. For their trouble, the proprietors of the turnpike collected tolls for some time in the 1800s. The following series of accident scene photographs from the Nassau County Police Museum Archives provides a revealing glimpse of the turnpike at various times in the 1930s and 1940s. Additional photographs date back even further. This photograph was taken just west of the corner at Jericho Turnpike and Jackson Avenue on September 5, 1942. The view, facing east, shows the Gold Medal Garage, owned by Henry Zeisner, who originally ran a blacksmith shop at this location.

94

This photograph, taken from South Oyster Bay Road just south of Jericho Turnpike on March 26, 1937, looks north on Jackson Avenue, with the Jackson property on the right. A close-up glimpse reveals several signs at the intersection, one pointing travelers to Jones Beach, which had been established as a public park 10 years earlier.

Facing south from the intersection of Jackson Avenue and Jericho Turnpike, this 1946 view shows South Oyster Bay Road before it was developed. Note the sandwich and refreshment stand to the right, which probably served hungry tourists from all over Long Island and New York City during its heyday.

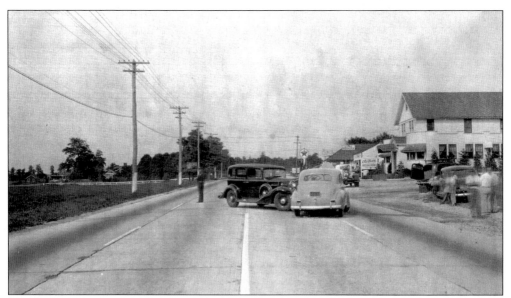

This September 5, 1942 photograph looks west on Jericho Turnpike from the intersection at Jackson Avenue. On the right, just west of present-day Florence Avenue, is Romaine's Restaurant, which had been Langon's Restaurant & Grill in the 1920s and 1930s.

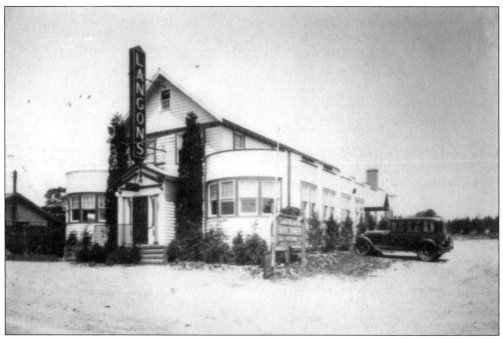

The second incarnation of the Ku Klux Klan was very active in Syosset and across Long Island during the 1920s, focusing much of its hatred toward the new wave of Catholic Italian immigrants. This may be why restaurateur Tom Langione shortened his name to Langon when he opened his restaurant on Jericho Turnpike c. 1926. Langon's enjoyed a successful run in the late 1920s, when it was a popular spot for wedding celebrations and other special events. The 50¢ luncheons and 75¢ shore dinners were also a big hit. (Randy Langione.)

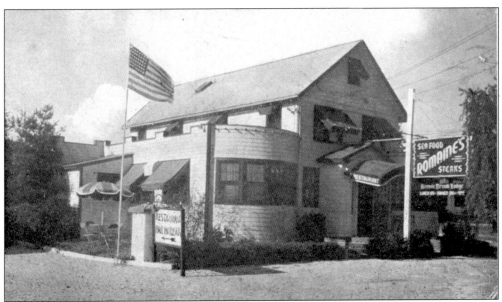

Unfortunately, the Depression of the 1930s hit hard at Langon's and Tom Langione eventually had to let his restaurant go. This 1946 advertisement for his successor, Romaine's, shows the effects of a rising cost of living. Lunch was now priced as high as 75¢ and dinner as high as $1. (Carl Baker.)

After leaving the restaurant business in the mid-1930s, Tom Langione built Lang's Locust Grove Deli for his son, Steven Langione, just north of the corner of Jericho Turnpike and Jackson Avenue. This brick building was still standing in 2001, as was Langione's former home, right next-door. (Randy Langione.)

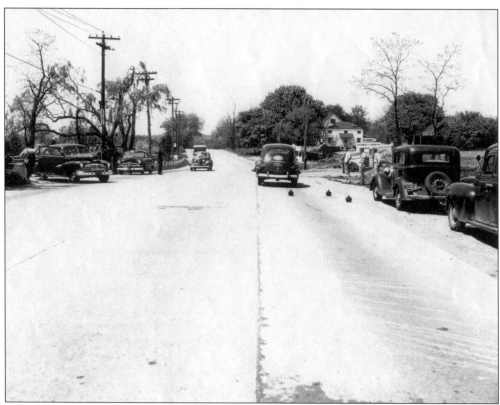

Returning to Jericho Turnpike, this May 1949 view faces farther west. On the right, a sign at the present-day Burke Lane invites home seekers to visit Syosset Gardens, a new development going up behind property that later became the Syosset Hospital. Syosset Gardens included some experimental homes built with steel foundations. (Nassau County Police Museum.)

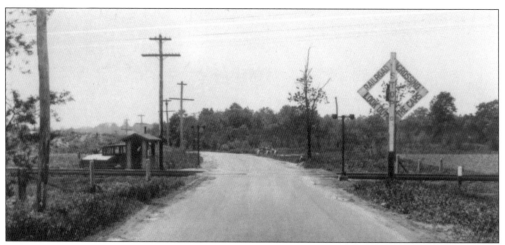

This April 1926 photograph, taken even farther west, shows the former street level railroad crossing just east of today's Underhill Boulevard. (Robert Emery LIRR Collection, SUNY Stony Brook Museum.)

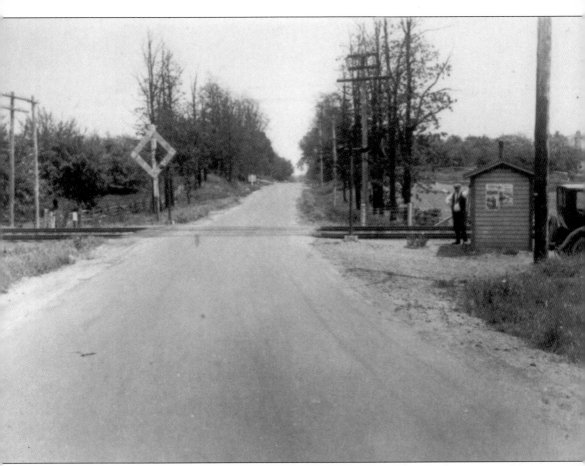

This photograph was taken the same day as the previous one, but facing east. The man standing against the booth (possibly Paddy O'Hagan) had the job of stopping traffic (automobiles and horse-drawn carriages) whenever a train passed. (Robert Emery LIRR Collection, SUNY Stony Brook Museum.)

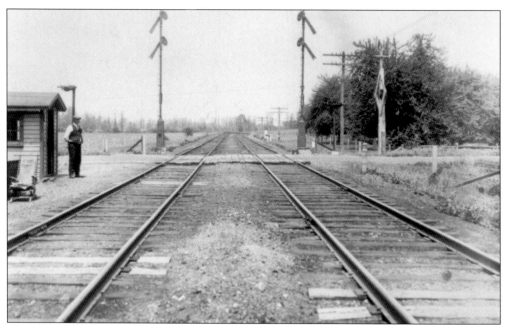

This view is from the railroad tracks, facing north, toward downtown Syosset. The present-day Underhill Boulevard is to the left. The street level crossing was replaced with an overpass in 1929. (Robert Emery LIRR Collection, SUNY Stony Brook Museum.)

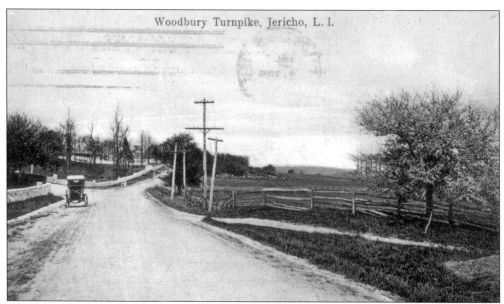

This early-1920s postcard, in which Jericho Turnpike is mislabeled the Woodbury Turnpike, appears to have been photographed even farther west than all the previous shots, somewhere in the vicinity of Robbins Lane. This determination is based on a comparison with the rolling terrain that exists on this part of the turnpike today and the fact that the location is noted as Jericho. (Carl Baker.)

Nine

WORLD WAR II

A surprise Japanese attack on the U.S. Naval Base Pearl at Harbor in December 1941 drew the United States into one of the bloodiest conflicts in its history. Suddenly, America was at war, not only with Japan but also with Germany and Italy. After a decade of economic struggle and diminished faith in the American Dream, small communities like Syosset were fired up with renewed patriotism and spirit. Young men like Henry Marzola, pictured in 1945 at the 3rd Air Force Headquarters in Louisiana, put down their farm tools and headed to the enlistment center to take up arms against "forces of evil" around the world. (Henry Marzola.)

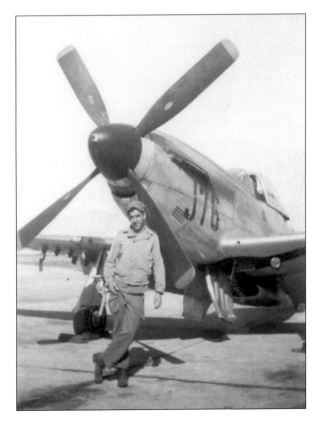

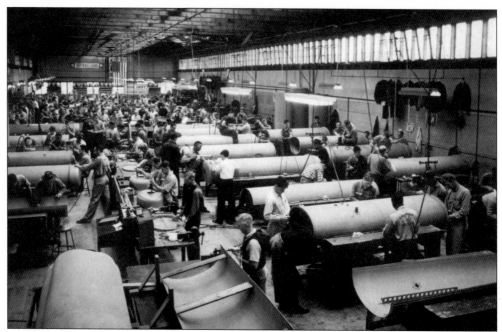

Almost overnight, Syosset's economy received a huge boost from several defense plants that sprang up all over the area. In February 1942, the Grumman Corporation opened Plant No. 12 on Jericho Turnpike, just west of Underhill Boulevard, to manufacture parts for military planes. Grumman was followed by the Sperry Corporation, Liberty Inc., and the Republic Corporation. (Grumman Historical Archives.)

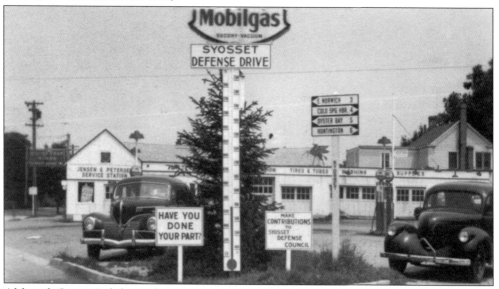

Although Syosset's defense plants employed many local men and women during the war, they also made Syosset a possible target for an enemy air attack. The prospect of an air strike by Axis forces prompted the fire department and other local organizations to institute a civil defense program, which helped pay for new fire and disaster equipment. The Syosset Defense Fund progress meter stood at the tip of the triangle of the Jensen and Petersen Mobil station, which had by then taken over the original Syosset Garage. (Pam Boslet Buskin.)

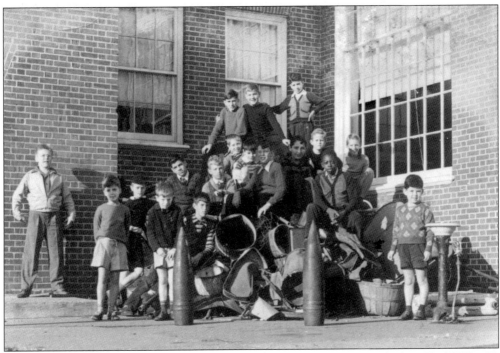

Even schoolchildren pitched in for America's defense effort during and after World War II. Here, a 1940s class at the Syosset School shows off scrap metal they collected for Syosset's defense drive. (Judith Manarel Plant.)

In December 1942, 19-year-old Patsy Pepe Jr. was drafted into the U.S. Air Force and was sent south to train as a gunner. When his squadron was called for duty, a stopover at Long Island's Mitchell Field was part of the itinerary. During a delay in the unit's departure, Pepe managed to "jump fence" and sneak back to Syosset to enjoy a few nights on the town with his old buddies. This was the last time he returned to his hometown; Sergeant Pepe's B24 bomber was shot down off the coast of Sardinia in 1944. His body was never recovered. (Frank Pepe.)

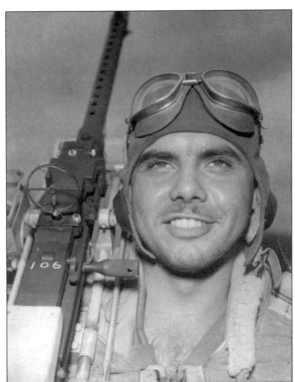

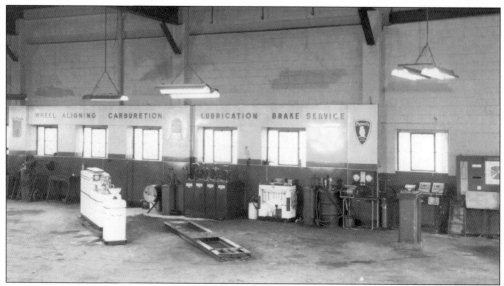

Just as Krebs and Schulz were completing their new, modern Syosset Garage, wartime rubber, steel, and gas rationing brought a severe slowdown to the auto industry. During these years, Krebs and Schulz leased their spacious new building to the Republic Corporation, which used it to assemble aircraft and submarine supplies. This interior shot was taken in 1948, after the garage was rebuilt and back in business after the war. (John Schulz Jr.)

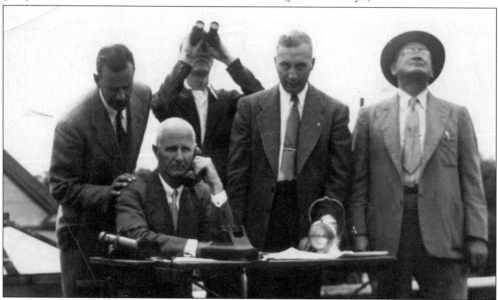

The roof of the new Republic facility made an ideal location for an Operation Alert lookout post. From here, enemy planes could be spotted coming over the horizon should the war ever spill into the United States. Volunteers manned the lookout tower through the night and also ensured that all houses and businesses pulled down their black shades after dark to mask any light that might be visible to enemy warplanes. Pictured on lookout duty are, from left to right, Frank Manarel (principal, Split Rock School), Albert Bayles, (first president, Syosset Bank), Robert Boslet (postmaster), John Martin (manager, Hempstead Bank), and Charles Krebs (building owner). (Judith Manarel Plant.)

Although he survived to become one of Syosset's longtime residents, Arnold Bocksell had a particularly horrific World War II experience. Captured in the Philippines along with approximately 12,000 other American soldiers in May 1942, 27-year-old Bocksell spent the balance of the war enduring brutal treatment in a Japanese prisoner-of-war camp. He later recounted his 39-month ordeal in a book entitled *Rice, Men, and Barbed Wire.* (Arnold Bocksell.)

Throughout the stressful war years, locals found solace in meeting friends and neighbors to discuss the events in Europe at local gathering places like the Boslet Inn, where Joseph Boslet Sr. is shown at the bar with two patrons in the early 1940s. The restaurant and bar's early success may have been due to Boslet's brilliant foresight when, in 1939, he invested in a brand-new entertainment gizmo called a television. Curious Syosset townspeople flocked to Boslet's at every opportunity to watch moving pictures on the nine-inch black-and-white screen. Located next to the Republic plant, Boslet's served hordes of defense workers at lunchtime each day. The Boslet family ran the inn as a bar-and-grill until 1952. (Pamela Boslet Buskin.)

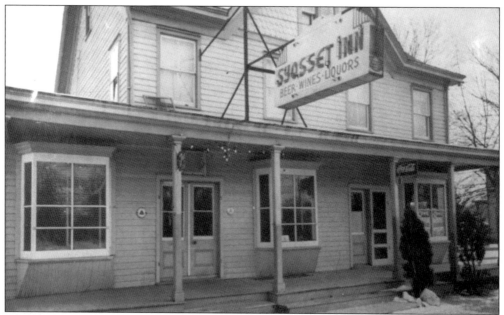

Another hot spot during the war was the Syosset Inn, which took over May's General Store, at the southeast corner of Convent Road and Jackson Avenue. Cornelius and Peg Moran purchased the Syosset Inn in 1940 and quickly established the restaurant and bar as a popular lunch spot for defense workers. When Peg Moran's brother, Ernie Kyle, became a partner in 1944, the establishment was renamed Moran and Kyle's Syosset Inn, shown *c.* 1941. (Mary Moran Kennedy.)

After hours, defense workers, shopkeepers, and farmers alike often found themselves at local taverns like Moran and Kyle's, drinking cold beer, dancing to Frank Sinatra records, and sharing letters from friends and family members on the battlefront. Of course, after dark, black shades were drawn over the windows so that the pub could not be easily spotted by advancing enemy planes. (Mary Moran Kennedy.)

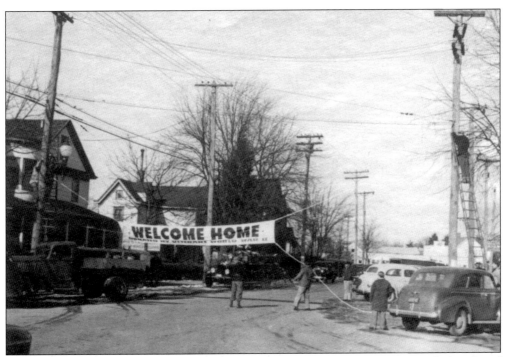

As patriotism reached a feverish pitch in 1942, Syosset war veterans came up with the idea of organizing the hamlet's first Memorial Day parade. Above and below, the first order of business was to hang a banner across Jackson Avenue, welcoming vets home. (Pamela Boslet Buskin.)

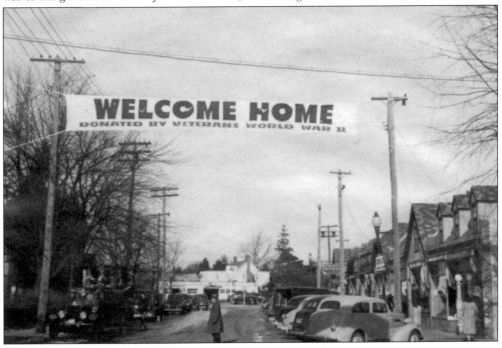

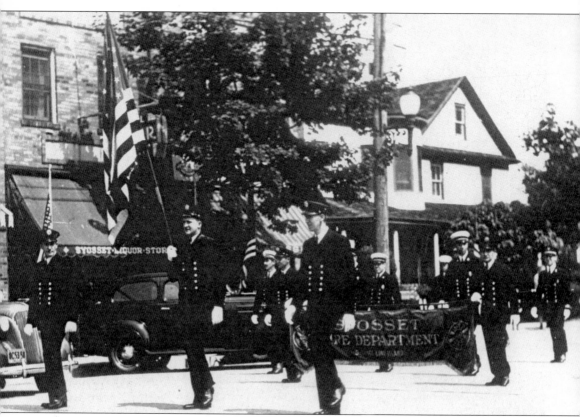

The first parade began at the firehouse on Muttontown Road, headed south on Jackson Avenue, and then looped back to the war memorial at the fork of Split Rock and Berry Hill Roads. There, parade marshall T.V. Summers addressed the crowd: "We are living today in very difficult times with a large part of the world engaged in war . . . It seems to me that we must pray for wise guidance and leadership and give every support to the president of the United States . . . I have no doubt that the people of Syosset will do their duty in the same manner as our ancestors did to preserve our great heritage of democracy and keep burning the torch of human liberty." (Syosset Public Library Local History Room.)

The original Syosset Memorial Park included an authentic military cannon and an honor roll of Syosset men who had served in World War I. When the park was dismantled in the 1940s, the cannon was sold to a scrap metal dealer. (Carl Baker.)

In the early 1950s, a new Memorial Park at the southwest corner of Underhill Boulevard and Jackson Avenue (photographed in 1991) included both the World War I and World War II monuments and became the site of the official Memorial Day ceremonies.

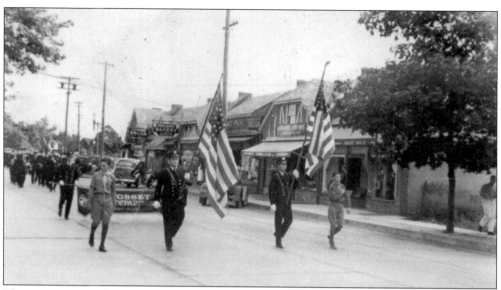

The wartime parades of the 1940s began a longstanding Syosset Memorial Day tradition. During times of peace, emphasis was usually placed on family fun, with barbecues, sack races, baseball games, and other activities taking place throughout the town all day long. Whether America was at war or at peace, year after year, the Memorial Day parades remained a highlight for residents of all ages. (Alan Boslet.)

HONOR ROLL

ALLISON, C.G.	ELLIOTT, B.	JOHANSSON, P.O.	MEYER, O.F.	RAGOZZINO, P.	ULMAN, M.
ALLISON, T.S. JR.		JOZWIAK, S.	MICHALOWSKI, S.F.	RAUSCH, C. JR.	URE, J.A.
AMATEIS, H.		JUSTICE, C.W.	MIDDENDORF, B.	RITCHIE, A.E.	
ARMSTRONG, J.	FARRELL, J.A.		MINARD, H.	ROBINSON, F.	
ANDREWS, A.T.	FOLEY, J.C.		MIRON, J.M.	RUTISHAUSER, E.	
ANTOSYN, E.	FRIEDRICHS, W.P.	KAISER, R.A.	MIRON, M.A.		VACCHINA, L.
ARNDT, O.		KANE, G.J.	MIRON, S.C.		VAN COTT, C.A.
		KATOWSKI, F.J.	MORAN, J.H.	SANKER, J.J.	VAN COTT, J.T.
		KEATING, T.R.	MORRIS, C.F.	SARGENT, A. JR.	VAN REES, C.H.
BAILEY, J.	GAIDA, G.	KIERNAN, B.		SATCHELL, I.F. JR.	VERMON, F.
BARONE, J.	GARLAND, R.L.	KOHLER, H.		SATCHELL, J.	VON WOLFFERSDORFF, O.T.
BASTINO, A.	GARVEY, C.J.	KOZAK, V.		SCHIESS, R.A.	VOORIS, B.B.
BASTON, A.	GENOVA, R.J.	KWIECIEN, P.P.		SCHUMACHER, C.E.	VOORHEST, J.A.
BORODAUCHUK, V.	GIANNETTA, R.J.		Mc AULIFFE, J.J.	SHEAN, E.T.	VOORHEST, L.R.
BOSLET, D.A.	GLENN, J.W.		Mc KINNEY, D.S.	SIMS, E.M.	
BOSLET, J.G. JR.	GORNEY, S.			SLOBODZIAN, J.	
BOSLET, R. J.	GRISCOM, B.W.			SMITH, D.M.	
BRAUN, T.W.	GUILLE, G.	LADD, D.	NOLBACK, P.P.	SMITH, E.B.	
BUDD, A.H.	GUILLE, L.	LANGLEY, J.T.	NORDQUIST, W.	SMITH, J.L.	
BURDEN, J.A.		LANGON, S.		SMITH, L.I.	
		LANOIR, J.		SMITH, R.C. JR.	
		LAYTON, W.	ODWAZNY, J.J.	STELLABOTTE, J.	WEIDNER, J.M.
	HAHN, C.W.	LEUTEMAN, A.H.	ODWAZNY, V.	STORTS, W.A.	WEINSTOCK, B.
	HAKKER, R.	LITTLEFIELD, H.N.	OSBORNE, D.W.	STROMER, P.	WICKERSHAM, C.W.
CARL, S.F.	HALLETT, J.B.	LORD, D.		SUMMERS, R.C.W.	WOOD, G.J.
CARNEY, W.P.	HALLETT, L.F. JR.	LORD, E.C. II		SUMMERS, S.V. JR.	WOZNIAK, K.
CHESHIRE, D.V.	HARRIGAN, W.F.	LORD, F.B. JR.	PALAMAR, M.	SVENINGSON, S.A.	WRIGHT, H.D.
CORCORAN, J.H.	HARRIS, N.K.	LORD, G. DeF. JR.	PATERSON, D.	SWINBURNE, L.	
COX, J.L.	HAVENS, B.	LYON, N.H.	PATTERSON, D.C.	SZILAGYI, L.	
CURRAN, H.M.	HAWXHURST, R.W.		PELKOWSKI, M.		
	HECK, G.C. JR.		PELL, J.H.G.		
	HENDRICKSON, J.W.		PEPE, C.		
DAY, J.	HENDRICKSON, R.M.		PEPE, D.		
DENNHARDT, F.	HICKS, A.J.		PEPE, P. JR.		ZDUNEK, C.
DEVERS, C.E.	HINES, J.J.		PESINKOWSKI, F.J.	TERRY, H.B.	ZELANO, J.A.
DEVERS, F.D.	HODA, J.	MACKENZIE, I.B.	PESINKOWSKI, T.	THIEGARDT, P.P.	ZGLIESEKY, C.
DeVINE, H.P. JR.	HODA, M. JR.	MARTIN, H.B.	POLZIN, J.P.	THOMAS, A.	
DICKEY, M.A.	HODA, P.	MARTIN, W.A.	POMPA, B.R.	TIFFANY, D.D.	
DITTA, J.	HODA, W.	MARZOLA, D.	POOLE, A. WAC	TIFFANY, G.S.	
DITTA, N.J.	HORN, K.	MATSCHAT, W.F. JR.	PUCCIO, J.A.	TIFFANY, P.J.	
DONALD, R.	HUNTER, J.	MAUTNER, W.J.	PUCCIO, M.J.	TITUS, C.A.	
DONOHUE, J.	HUNTER, G.	MEYER, C.	PUCCIO, S.P.	TITUS, S.D.	
DOSS, W.J.		MEYER, C.C. JR.	PUNTON, G.J.	TRENTHAM, H.R.	

Photographed in the mid-1940s, Syosset's new World War II Honor Roll stood on a triangle between Fred's Barbershop and Weinstock's Stationery Store, before an additional storefront occupied the space. Eleven of Syosset's servicemen lost their lives in the war. They are Charles Anker, Robert Hendrickson, Vladimir Kozak, John Lanoir, Peter Nalback, Patsy Pepe Jr., Edward Taylor, George Tiffany, J.M. Weidner, C. Zdunek, and Clemes Zgliesky. (Frank Pepe.)

Ten

BEYOND THE 1950s

As servicemen such as Dan Pepe and Joe Ditta returned from duty after World War II, their old neighborhood was on the verge of major change. Farms were losing workers to the higher-paying defense plants and were also succumbing to a devastating potato blight. By the end of the 1940s, many potato fields had been completely destroyed, causing a panic among farmers who had built their livelihoods around the precious "'tater." The war's end also brought closure to lucrative government-subsidized potato-farming contracts. Real estate developers, anticipating a need for postwar housing, soon came knocking on the farmers' doors with offers that many could not pass up.

Likewise, by this time, the Gold Coast era had come to an end, and estate owners in Syosset and the surrounding areas were selling their land and moving away. What happened in the years that followed is the subject of another book to be written at another time. However, the following pages provide a brief overview of the decades immediately following World War II, the decades that shaped Syosset as we know it today. (Frank Pepe.)

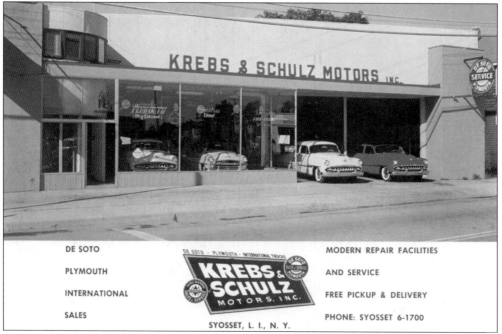

The new Krebs & Schulz Motors, shown here in the early 1950s, incorporated both the car care center and the Plymouth-DeSoto dealership into one ultramodern storefront at the northwest corner of Whitney and Jackson Avenues. Eventually, the partners closed their auto dealership and garage, sold the building to the Hempstead Bank, and shifted their focus to K & S Transportation, which eventually took up residence on Underhill Boulevard. (John Schulz Jr.)

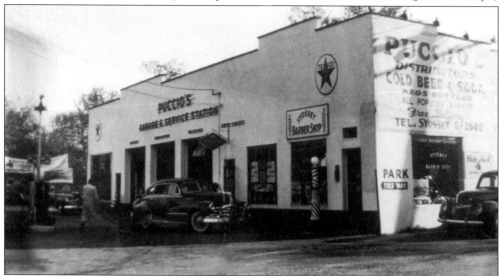

After serving in World War II, Marty and Phil Puccio opened a service station on Jackson Avenue between Willis and Walters Avenue in 1946. A year later, Joe Puccio started a beverage distributorship in the same building with his brother Sam Puccio. The eldest brother, Tony Puccio, had a barbershop at the same address, which he later turned over to Rocco Cuccino, Sadie Puccio's husband. This photograph dates from the late 1940s. (Rosaria Cuccino Glaser.)

When the original Syosset Inn burned down in 1953, it was replaced by the new, fire-resistant brick building shown above *c.* 1954. Three years later, Cornelius Moran passed away and Ernie Kyle took over the restaurant, sharing the responsibilities with his wife. Eventually, the name was changed to Kyle & Moran's and remained that way until the inn was sold in 1984. (Mary Moran Kennedy.)

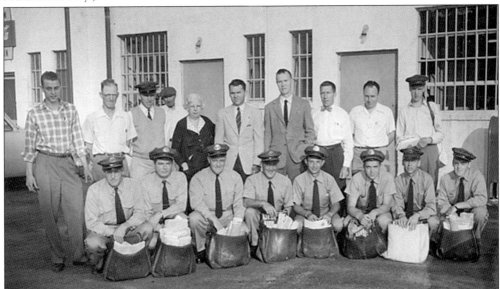

In February 1950, the Syosset Post Office moved to a larger storefront further north on Jackson Avenue and began home delivery for the first time. For many, home delivery marked the end of an era. Now the post office, which had once been a social gathering spot, was just a place to visit every so often when one needed to purchase stamps or send a package. This photograph was taken behind the new post office in 1955. (Pamela Boslet Buskin.)

In 1950, Harry Sweeny converted part of the Jackson property, including its icehouse and barn, into a popular petting zoo called Lollipop Farm, photographed in 1952. The zoo gave post-farm generation children a chance to visit face-to-face with piglets, sheep, chickens, and other barnyard creatures that were typical of the Syosset and Long Island landscape of their parents' day. (Tony Maimone.)

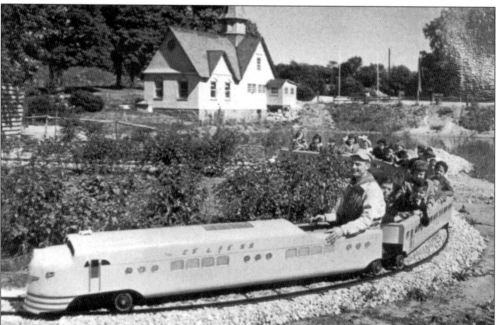

One of the most popular attractions at Lollipop Farm was the train ride, which took youngsters on a journey past the barns and stables that housed the animals. The rail line was no more than a few thousand feet, but in the memories of children who rode it, the Lollipop Line seemed to last for miles.

When Lollipop Farm closed down in the early 1970s, the icehouse and stable were demolished, the pond was filled in, and retail stores took over the property. (Syosset Public Library Local History Room.)

The most popular fast-food restaurant on Long Island during the 1950s was Wetson's Hamburgers, which thrived on Jericho Turnpike and Humphrey Drive until McDonald's opened up down the road. A hamburger cost less than a quarter, and an ample order of fries was a dime. Eventually, Burger King bought this site and Wetson's vanished from Long Island forever. (Syosset High School Yearbook, 1967.)

Wetson's main competition during the 1950s and 1960s was Burger Square (also known as "Square Burger"), a typical 1950s-style fast-food restaurant, complete with carhops, who served customers right in their automobiles. Situated just west of Route 135, Burger Square's property was bought by McDonald's Hamburgers in 1971. Behind Burger Square in the 1960s and 1970s was Frank Weber's Golf Range and Miniature Golf Course. (Syosset High School Yearbook, 1967.)

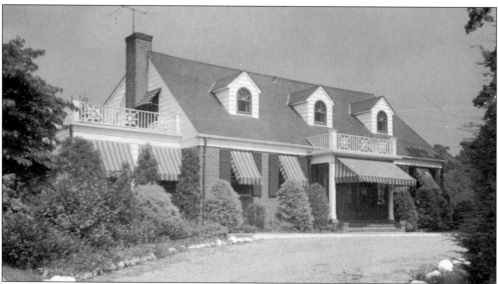

From 1954 to 1989, the Viennese Coach was a favorite dining establishment of Syosset-Woodbury residents. Originally owned by Rustan Lundstrum and Thure Johannsen and later operated by Lundstrum's son, Leonard Lundstrum, the Viennese Coach took over a building that had previously housed several restaurants and their owners. When Lundstrum and Johannsen bought the restaurant, they gutted the apartments upstairs and built additional dining and catering rooms in which many Syosset families celebrated special events over the years. (Leonard Lundstrum.)

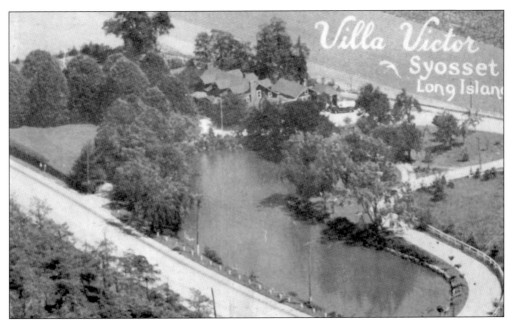

Built on what was purported to be a former British army camp, the Villa Victor, founded in 1934, was particularly popular between 1964 and 1966, when host Rudy Zani advertised that he would pilot guests by helicopter to and from the Flushing World's Fair for $15. The restaurant, adjacent to a natural pond from which British soldiers probably once filled their canteens, was a popular dining and catering establishment into the 21st century. (Carl Baker.)

The Crossways Industrial Park, built on 137 acres of the former Edward Tinker estate, opened in 1963 with Grumman Aircraft, Barron's Publishing, Harvey Radio, and many other major corporations as its first tenants. The Syosset School District purchased an additional 10 acres of the estate to build the Harry B. Thompson Jr. High School. Route 135 (the Seaford-Oyster Bay Expressway) was built through the western end of this property in 1962. (Syosset Public Library Local History Room.)

SYOSSET

HOMETOWN U.S.A.

OUR NEW SYOSSET–WOODBURY COMMUNITY PARK

When investment banker Edward Tinker passed away in 1959, his 200-acre estate was sold with the provision that a portion be used for public recreation. To the delight of Syosset-Woodbury residents, many of whom had grown up on the concrete playgrounds of Brooklyn and Queens, 46 acres were set aside for a sprawling community park, complete with an enormous swimming pool, spacious playground, picnic areas, several ball fields, a skating rink, tennis courts, and an indoor recreation center. The Syosset-Woodbury Community Park was dedicated on June 13, 1965. (Syosset Public Library Local History Room.)

118

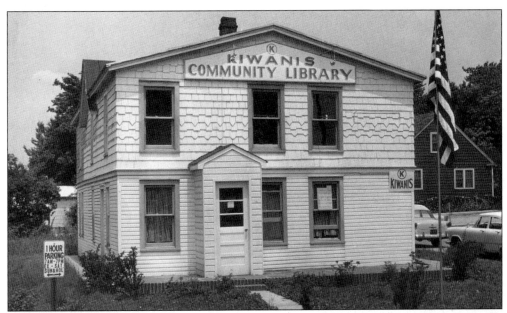

Though several earlier attempts at organizing public libraries in Syosset had met with only marginal success, the first to take root was the Kiwanis subscription library at 14 Roosevelt Street. The all-volunteer library, founded in 1958, was supported mostly by an annual $5 family membership fee. In 1961, commercial developers bought the land and served the Kiwanis Club with an eviction notice. Fortunately, a few months earlier, voters had approved the establishment of a new Syosset public library, to which the Kiwanis Library donated all of its holdings. (Syosset Public Library Local History Room.)

In 1962, the brand-new Syosset Public Library took over the former post office at 20 Cold Spring Road. Within a year, much larger quarters were needed, so the library relocated to 29 Jackson Avenue, where this photograph was taken in 1963. This facility operated until February 1970, when a new, state-of-the-art library complex was built on the former Kennedy farm on South Oyster Bay Road. (Syosset Public Library Local History Room.)

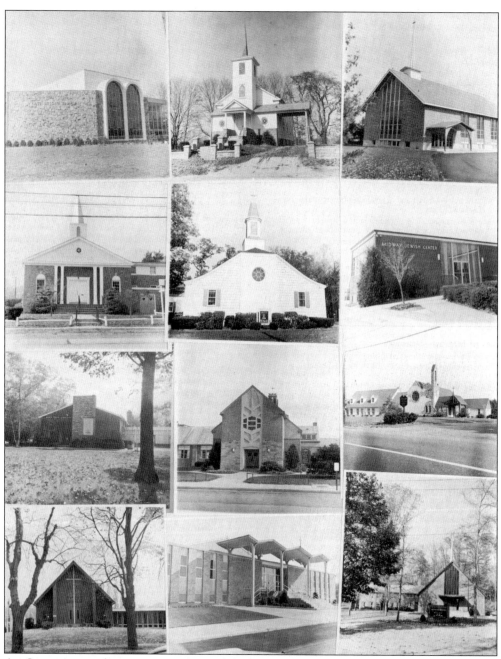

As Syosset's population increased, so did the need for new, larger houses of worship. Syosset-Woodbury's religious institutions in the years after World War II were, from left to right, top to bottom, East Nassau Jewish Center (1957), Original Woodbury Methodist Church (1844), Bible Baptist Church (1962), Syosset Gospel Church (1957), Community Church (1861), Midway Jewish Center (1953), North Shore Synagogue (1953), St. Edward Confessor (1952), St. Bede's Episcopal Church (1953), Faith Lutheran Church (1952), Holy Name of Jesus (1964), and New Woodbury Methodist Church (1959). (Syosset Public Library Local History Room.)

The construction of Underhill Boulevard in 1957–1958 created a much-needed alternative route between the downtown area and Jericho Turnpike. Here, workers are shown laying the roadbed just southwest of Tredwell Avenue after cutting through the former Underhill farm to clear the right of way. (Pamela Boslet Buskin.)

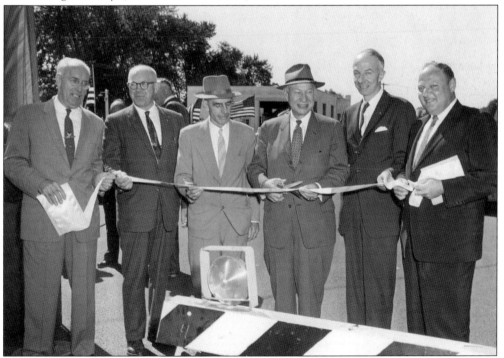

The ribbon-cutting ceremony for Underhill Boulevard on September 29, 1958, attracted many local dignitaries. Shown here, from left to right, are Lewis Waters (former Town of Oyster Bay supervisor), John C. Schulz (chamber of commerce president), unidentified, J. Russel Sprague (Nassau County executive), John J. Burns (Town of Oyster Bay supervisor), and Abby Katzman (attorney). Underhill Boulevard later housed major corporations such as Georgia Pacific, Singer Sewing Machine, and Kollsman Instrument. (John Schulz Jr.)

THE ORIGINAL

CHRISTIANO'S

RESTAURANT
ESTABLISHED 1958

19 IRA ROAD
SYOSSET, NY
(516)921-5588

"I'll meet you any time you want in our Italian restaurant . . ." went the lyrics to Billy Joel's "Scenes from an Italian Restaurant." The song is a tribute to Syosset's Christiano's, which opened on Ira Road in 1958 and was a hot spot for great Italian meals for many decades to follow. Joel, a Rock & Roll Hall of Fame singer-songwriter who had a 1977 chart-topping hit with his homage to Christiano's, was a frequent guest at the restaurant both before and after his rise to superstardom in the 1970s.

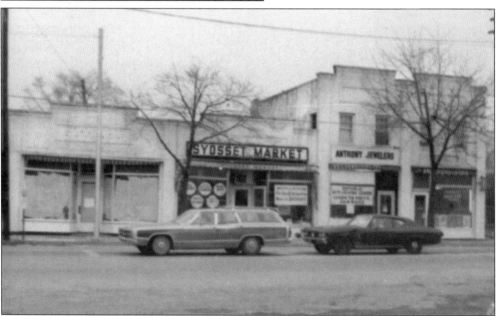

Leases for stores on the west side of Jackson Avenue began to expire in the early 1970s. Rumors around town were that the Long Island Savings Bank was going to take over the corner, demolish all the stores, and build a gargantuan, multilevel bank right in the middle of downtown Syosset. Not many believed it. (Tony Maimone.)

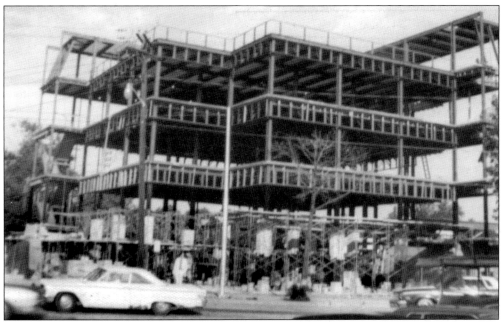

All bets were off when construction at the corner of Jackson and Underhill began in 1974. The imposing, marble-faced structure certainly changed the look and feel of the downtown area forever. Many residents, both lifetime residents and newcomers, were not happy. During the bank's first year, local teens, on more than one occasion, filled the bank's outdoor spouting fountain with soapsuds, which proceeded to spill onto Jackson Avenue. After a few such incidents, the fountain was filled in with dirt and trees were planted in its place. (Tony Maimone.)

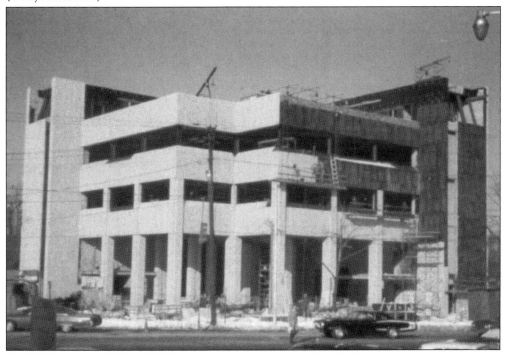

Whether for or against the new bank building, amateur shutterbugs such as Tony Maimone found its towering roof to be a great place from which to photograph the downtown area. This 1974 photograph shows some of the mainstay shops in town throughout the 1950s, 1960s, and 1970s, including, from left to right, Syosset Sweet Shop, Syosset Surgical Supplies, Fieldwood Men's Store, Lady Fieldwood, Syosset Sport Center, Fred's Barbershop, and Anthony Jewelers. (Tony Maimone.)

Groundbreaking for the new Syosset High School took place in 1955, just one year after the formation of the Syosset Central School District, which incorporated all the individual schools of Syosset, Woodbury, and Locust Grove. Shown at the ceremony, from left to right, are, Brad Clark (perhaps one of the architects), Frank Manarel (future assistant superintendent) William McGurk (school board member), and Ernest Weinrich (superintendent). (Bette Manarel.)

Syosset High School was built on farmland that previously belonged to the Van Sise family, who had used it for growing strawberries and potatoes, among other crops. The school opened in September 1956, with an enrollment of 991 students. From then on, high school-aged students from Syosset and Woodbury no longer had to face the strenuous ordeal of traveling to Hicksville, Oyster Bay, or Huntington each day. Suddenly, Syosset teenagers had a home. The auditorium takes shape above.

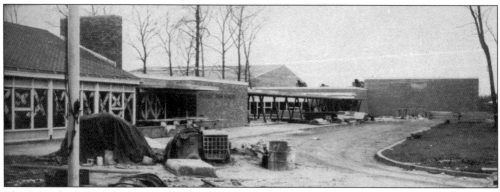

The completion of the high school was not the only monumental feat of the newly formed Syosset Central School District during the 1950s and early 1960s. In 1954, the South Grove and Village Elementary Schools opened, followed a year later by four more elementary schools: J. Irving Baylis, T.V. Summers, Walt Whitman, and Alice B. Willets. In 1957, the Berry Hill School held its first classes, followed by Robbins Lane in 1958. As America's baby boom generation reached high school age, overcrowding at the new Syosset High School prompted the school board to establish two junior high schools: Southwoods, on the north side in 1959, and Harry B. Thompson, on the fast-expanding south side in 1961. The high school was nearing completion when this photograph was taken in early 1956.

On November 25, 1962, the author was born to Dr. Leonard and Marie Montalbano of 27 Hillvale Road, Syosset. The Syosset in which he and his friends grew up in the 1960s and 1970s was a world away from the old-time Syosset in this book. Perhaps some other writer will someday wonder what life in Syosset was like during those years . . .